Being and Circumstance
Notes Toward a Conditional Art

Being and Circumstance
Notes Toward a Conditional Art

by Robert Irwin

The Lapis Press
in conjunction with The Pace Gallery
and the San Francisco Museum of Modern Art

This book has been published in conjunction with these Robert Irwin exhibitions:

The Pace Gallery, New York
13 September to 12 October 1985

San Francisco Museum of Modern Art
29 September to 24 November 1985

Edited by Lawrence Weschler

The Lapis Press
P.O. Box 5408, Larkspur Landing, Calif. 94939
(415) 461-5275

Cover: "Two Running Violet V Forms," Stuart Foundation Sculpture Collection, University of California, San Diego.

ISBN: 0-932499-07-4
Library of Congress Catalogue Card No. 85-081088

Contents

Introduction

Change

One must make an optic, one must see nature as no one has seen it before. — Paul Cézanne

Change is the most basic condition (physic) of our universe. In its dynamic, change (alongside time and space) constitutes a given in all things, and is indeed what we are talking about when we speak of the phenomenal in perception. Most critically, change is the key physical and physiological factor in our being able to perceive at all. Our perceptual process is a kind of "perpetual motion" assimilator. No change, no perceptual consciousness. So while it is perfectly understandable that the overwhelming majority of our conceptual energies are spent on organizing this myriad of perceptual data into some form of "familiar picture" we can work and live with, what is not so understandable is how much of those intellectual energies have been spent on trying to avoid this fact and its effects on our lives. Countless fortresses of "concrete" thought have been thrown up to transcend this inevitability, all of which, in the end, have proven to be so much wishful thinking.

In our everyday lives, this sort of wishful thinking, while providing some comfort, has caused no end of confusion. While on the one hand, you can often hear it said of change that "nothing is ever really new, everything just repeats itself constantly," on the other hand, you will just as often hear it said that "while everything may repeat itself, no two moments are ever really exactly the same." While both of these intuitions have a ring of recognition (truth) about them, more importantly, one is not resolvable to the other, leaving us with the subtle recognition that the real character of "change" must now reside in some ephemeral increment between the two. But such subtlety is seldom, if ever, grounds for how we practice, so instead we are continually focusing our attention on the more obvious subsidiary properties of those accumulative *effects of "change" on things*, leading us mistakenly to identify "change" as being one and the same as those events. (We make the same objective error with both "time" and "space." For example, we once supposed Euclid's geometry was an exact description of the external world, when the only world of which it is an exact

description is the world of Euclidean geometry. The same can be said, for example, about the objective illusion of point perspective once so persuasive in pictorial painting.) All together, this points up the inherent weaknesses (confusions) generated by objective thought when it takes perception away from the phenomenal and tries to tie it directly to a "thingness."

Given this bias going in, it is no wonder we can never make sense of the phenomenal in consciousness. What can we expect to know when we insist on predetermining what is possible by positioning as fundamental the proposition of a simplistic and absolute dichotomy between "the perceiver" and "the thing perceived" —a beginning that obviously does not begin at the beginning. Even a moment of observation will tell us that our sense perception presents us with something much more complex (subtle), and a second moment of reflection will tell us that this election of *something* out of the whole complexity of the phenomenal requires an added, and very different, process of intellection.

What our perception presents us with (at every moment) is an infinitely complex, dynamic, whole envelope of the world and our being in it. The fact that we take this for granted (as a given) speaks not for its insignificance. On the contrary, it is, in part, an explanation of our perceptions' extraordinary "from-to" character. Let me paraphrase Michael Polyani's "personal knowledge" to make this point. Picture a blind man probing his way with a cane. While he is alert to the feelings in the hand holding the cane, the crucial distinction may be defined by saying that these feelings are not watched in themselves, but that he watches something else by way of them, that is, by keeping aware of them. He has a *subsidiary awareness* of the feelings in his hand, feelings which are merged into a *focal awareness* at the end of the cane, constituting two kinds of awareness that are *mutually exclusive*—"from awareness" and "focal awareness." There is here a particularly interesting phenomenal transformation. The sensations of the cane on his hand (the surface of the cane as it touches the palm of his hand, etc.) are lost. Instead, he feels the end of the cane as it touches an object. (The semantic aspect of this transformation is that the information the man gets by feeling with the cane is the *meaning* of the tactile experience.) Subsidiaries exist, as such, by bearing on the focus *to* which we are attending *from* them, and are integrated one to the

other by the act of a person, and last only as long as *a person, the knower*, sustains this integration by *indwelling* (living in) them. The proof of the existence of two kinds of awareness comes when we try to observe how we do all this. If our blind man shifts his attention from the tip of his cane to his hand, the meaning on the end of the cane disappears (or becomes something else). Deprived of the meaning of its actions, any description of the process is merely a description of the "mechanics" and not of perception at all.

In summary, we can thus state that *all perceptual knowing is knowning in action (change) and the equivalent of the phenomenal.*

Inquiry

By the turn of this century, nothing, absolutely nothing, was on certain ground; everything was being challenged; this is the main fact of our lives. — Alfred North Whitehead

Change as we experience it in our everyday lives is normally *homogeneous.* As if scaling rungs on a ladder, we appear to progress upward, trading one idea for another in a series of closely-integrated steps. That is, as long as our most basic concepts (grounds) remain intact and continue to provide us with an orderly progression of answers for our practices, and so long as the grounds of our practices remain constant (successful) long enough, a set of curious transformations in our understanding will take place over a period of generations, allowing the grounds of our most basic assumptions, over extended time, to take on the character of hidden orthodoxies (concepts in effect become beliefs, contingent facts become truths, etc.). Each subsequent generation comes to know the actual grounds of the originary concept less and less (this both as gain and loss) as each new generation is increasingly educated to the intricacies (sophistications) of "its" application as form (practice), the successes of which lead us to a further belief in their eternal correctness. Such belief becomes, with reason, the ultimate opiate in our lives. So it is easy to understand our reluctance and major discomfort when, in fact, it is challenged.

Radical change in our lives occurs when the methods of our time-worn practices, checked and rechecked, are unable to account for a growing accumulation of instances and questions to the contrary; and we are forced to go deeper (to expose our hidden orthodoxies). For this purpose, we begin in the worst of all places— at the very center of our sophistication as practitioners, enfolded in the layers of our operative (objective) structures, and bathed in the light of their prior successes. This is what is meant by an "existential dilemma." For holding our questions, we need to attain an uncommitted bare-bones ground where we can ask, "How might it be otherwise?" And to gain this ground, we can only begin by confronting our own beliefs.

As one educated and practiced as a painter, my first hint (intuition) that the world of my perceptual and aesthetic concerns might not begin and end at the edge of my canvas was something that had no tangible reality. But my question would not go away and was soon joined by others. What kind of a "reality" was this that allowed itself such abstraction as to demand that the world end at the edge of my canvas? Yet what kind of a world would it be if there were no such limits? And is not the idea of a non-object art a contradiction in terms? What would this art be *made* of? Where would it exist? And how would we come to know it, let alone judge it? Yet again, if we are to continue to take the words "aesthetics" and "perception" as having a serious bearing on art, can we simply continue to hold the dialogue of art to be subsumable to the making of objects? The surprise for me, when I stopped painting, was not the loss of something to do with my hands or the loss of my visibility (viability) as an "artist," but rather the loss of my thinking form (loss = gain?) the realization that painting had been both my process for selection and ordering of things and my philosophic method, and that the reality that had come to order my paintings was the reality that had come to order my life. Needless to say, such a loss is unsettling.

For my generation, to regain the necessary balance to pursue the process of peeling back the layers of our world—i.e., to deal with the questions posed by a nonobjective art — certain things needed to be kept in focus.

Since we obviously will have no immediate answers, we must first check and recheck the quality of our questions to make sure

they still hold. For example, while in the short term we won't be able to resolve the resultant practical problems, there is no legitimate way we can answer the last question asked above in the affirmative. Second, ideas (questions) are meaningless unless we let them affect (change) our lives. And third, it is most critical to keep in mind that this process is not *in itself* a negative one, that the old concepts are not *in themselves* untrue, only that they have become incapable of satisfying our extended questioning. For example, not a single concept of Newton's physics, which was once taught as The Whole Truth, has not now been replaced. What we know now, which we did not know before, are the limitations of his physics. So it is still useful, but just not true in the sense we once believed. In this same sense, the statement "painting is dead" is both negative and false, and useless as well. But while painting is not dead, we certainly do not view it with the same convictions we once did.

There is another (sometimes volatile) point that needs to be made with regard to the differences between pure inquiry (deep change) and social action. First, any action is defined by the basis upon which it makes its principal decisions, i.e., politics *is* politics. It is of only *secondary* interest what form is used (e.g., painting, picketing, wall graffiti, etc., deployed in order to make a political view known). In inquiry, the facts of our loss are for the moment limited to us. To anyone not sharing our questions, our process of confronting our beliefs and peeling back their established values[1] can only appear irrational, anti-social, or nihilistic (which explains, in part, the myths abounding around the social behavior of modern artists). Keep in mind that there is no good reason, as yet, why anyone else should agree with us, let alone change their lives. As imperative as this change may become for us, before we can aspire to move the whole of civilization to stand on new and untested grounds (note: *a second motive is now appended to the first*), something more complex and orderly must take place. But make no mistake, for in its proper course, that *is* what is at stake

1. This requires an unusual technique, an unreality-adapted posture for inquiry, in which the normal reinforcements – fruition, proof, feedback – are given up for the moment.

here. For change at the very base of our understanding will necessitate change in every facet of our lives, even if the implementation of that change may not come for years . . .

By now, it must be clear that both "relativity" in science and "modernism" in art constitute histories of radical change. The evidence for each is quite clear. As for art, only two hundred years ago we were deeply committed to the *truth* of a highly sophisticated, and quite beautiful, pictorial reality. In this relatively short period of time, we have witnessed the loss of the belief in a transcendent content and its replacement first by a terrestrial subject, and in its turn by the commonplace. We have seen art's pictorial literalness (structure) questioned by a speculative impressionism, a subjective expressionism, and, in *its* turn, replaced by a new pictorial structure in cubism, such that finally the canons of a classical reality (beauty) have been rejected all together by non-sense (Dada).

We have now arrived, to paraphrase Kasimir Malevich, in a place where there is no more likeness of reality, no idealistic images, no more things, nothing but a bare-bones desert.

But here, in this desert, we can now begin to question how it might be otherwise.

Qualities

Nonfigurative art brings to an end the ancient culture of art.
The culture of particular form is approaching its end. The
culture of determined relations has begun. — Piet Mondrian

What we have witnessed in this history of modern art is the de-structuring of meaning. (Keep in mind, meaning in objective thought is assigned collectively, in retrospect, as a measure of the *effects* of our ideas or actions—and not as a measure of the ideas or actions per se. It is always therefore a sort of functionalized historical summary.) Here in the "desert" we are confronted with the bare bones of our pictorial logic and how that logic has structured our perception in the world. Here we also find the openness to look again.

In the pictorial, objective world view, as artists we invest our mark(s) | with meanings.

In the beginning they simply acquire this "meaning" by virtue of their being intended, as against being accidental or found. This "meaning" has the effect of raising the mark out of, above, its incidental surrounding, thereby establishing the fundamental figure-and-ground relationship: |

In objective thought we compound this basic relationship to act in terms of a positive and a negative ("particular form" and the space around it) by raising the level of meaning invested in the mark. ⊤

In art we further transpose this mark so that it becomes the more complex "image form" (this "figuration" is a representation of something, in absentia, previously known otherwise) which we then invest with meaning-content. Now, each time we increase the level of the meaning-content invested in our mark, +

we raise its power. This process repeated over and over again will result in the power of a hierarchy of meanings becoming intimately connected to the mark. †

The dichotomies of figure-ground, positive-negative, thing-nonthing, meaningful-meaningless will even come to determine what is seen and unseen as well as real and unreal. Our perception in the world, once it has become thus structured, simply omits or habituates out (ignores) that which is deemed to have no value. Once this principle of abstraction is established, we can carry over its logic to apply more generally. For example, the painting's frame now acts as a container, its edges literally defining perceptual boundaries between what is to be seen and what isn't. If it should strike you as curious that I use the word "abstraction" to apply here at the very base of pictorial logic, I might note that it strikes me as equally curious that we've come to use the word to describe its opposite in nonobjective art. But the answer to this



riddle is fairly simple. Over time, we've become so convinced by our pictorial logic as to see *in it* the measure of reality. So much so that when modern art moved away from its pictorialness, it could only be seen as an abstraction from this *standard of reality*, thereby creating a second-generation use of the word. In this way the insistence in modern art on the unique "singularity" of art – i.e., "a painting is a painting" – has exposed the fundamental duality (abstraction) inherent in figurative art.

This logic of abstraction and containment for painting applies equally for the object in sculpture. Picture in your mind's eye a waterglass. Now, in pictorial (objective) art, the idea was to fill this "container" up with as much meaning-content as possible; and when the level of content was sufficiently meaningful, this glass (art object) would begin to exist in the vacuum of its "meaning" and, in effect, would become portable – that is, able to transcend the conditions of its immediate circumstances, which, in turn, could now be dismissed as incidental. In this way, I can make my art-object in one set of circumstances (my studio) and move it to another set of circumstances (my gallery) without anything of "real" consequence being altered or lost. Having once accomplished this simple feat of portability, I can compound this logic to carry my art-object (say, from West Coast to East Coast), or, if my "content" should approach a "universal," I can even think of moving it from one culture to another (say, from L.A. to India) and expect it to be equally well understood wherever I take it. Finally, if the meaning-content of my art is of a true essence – a Platonic[1] ideal? – I can carry this logic to its ultimate aspiration: Art as transcendent; Art as timeless.

To gain access to the phenomenal, nonobjective world view, however, picture the process reversed. Our waterglass now is slowly drained of its meaning-content – this was the history of art across the 19th century – until only the glass stands before us. The unenhanced, unadorned, "minimal" pure form. Artists in our time have already carried this process of "resolution" to its final set of questions. From Duchamp's "Ready-Mades" *found objects*, to Pollock's first-drip *accidentalness* and John Cage's experiments with

———

1. Plato, of course, never saw art as having the potential for ideal form

chance, the fundamental issues of art's "intendedness," vis-à-vis the "accidental," have been put into a new perspective. Earlier we touched on the assignment of "meaning," in the objective sense of that term, as "being made up collectively in retrospect." Juxtaposed to this idea, we can now state a principle of nonobjective art. **You cannot correctly call any human action either creative or free if the individual does not participate directly in the setting, and intending, of his or her own meaning.**

In the flattening of pictorial space you will recognize the parallel flattening of the objective hierarchical meaning-structure (the red robe of the King of Kings becomes, in turn, the red robe of a king, the red coat of a Burgermeister, the red dress of the girl next door, a red cloth, and finally the color, the pure phenomenon, red) as the principal determinate of human value (drawn in terms of such conceptual "ideals" as "the laws of nature," "the rules of logic," or a "God in the heavens," etc.). In its place, we now find the possibility of a fully integrated structure in which **the determination of value lies directly in the deliberations of the experiencing individual. Only subsequently does that individual enter into the collective bargaining that eventually makes up those more general social agreements we call cultural values.** This is a second principle of nonobjective art.

Of course, no idea of any fundamental consequence ever goes into the society whole (or overnight): if it did, society, with its low tolerance for change, would in all likelihood O.D. The actual process of social innovation takes many generations and requires that numerous roles be played out. It is also no accident or simple oversight that the early deliberations as to the acceptability of a new idea's consequences will remain oblique to society's general concerns, and instead be worked out within the discipline of its initiation. Demands that art service immediate social ambitions are irresponsible. In this sense, "art" is a discipline, and only later a practice. A radical change in our social fabric is inherently very precarious. A radical change in our values needs to arise as an imperative in the individual's creative action (it is as part of this process that "art's" principal role lies) and it comes to exist as a collective form only through a series of orderly phases (it is as a part of this process of innovation that "art" as a discipline participates). The idea that values can be applied to a society, either

administered from on high by religious or secular forces, or forced on that society by an "enlightened" few (no matter how well meaning?), radicalizing it from the outside – are both visions (compounded motives) equally steeped in pure Machiavellian ambition.

The tenets of nonobjective art were first stated clearly by Mondrian and Malevich.[2] Subsequently, the first group of artists to test and practice this "art-as-art" were the American Abstract Expressionists. That the implications of the "flattened value structure" were not generally understood in their abstract-expressionist painterly form is no surprise. Radical change in its originary form seldom, if ever, is. The first step by which the social innovation of the "idea" addresses this problem of recognition is one of placing the new "idea" into an old and familiar context. This would explain the arrival of "pop art" on the heels of abstract expressionism – with Warhol's Campbell's soup can (lost value) presented in a literal way (familiar form). This, in due time, led to the deeper innovation (commonizing) of the "idea" – a pickup truck in front of an all-night diner (lost value) rendered in the old and beloved high realism. Now everyone is confronted with the *loss*, and the need to search out the *gain*. Note: instead of going into society whole, the idea is always wedded, in some form, to previously existing practice. Further, there are generally three "second generations" in the wake of any path-breaking "first generation" – *one* which practices the first generation's expertise, *one* that processes its social innovation (the above example), and *one* that addresses its legacy of questions. In the beginning, the former are recognized as the heirs apparent; but over extended-time, the last one prevails. This explains, in part, the confusion generated by trying to measure those short-term swings of action and reaction as overly significant.

In what way does the "mark" now exist for us? More precisely, what is it we actually indicate, or mean, when we now use the term "art" – or, for that matter, the term "reality"?

If we remove the mark, the frame, the object, and the art place

2. "Natural Reality and Abstract Reality," Piet Mondrian, 1919. "Suprematism," Kasimir Malevich, 1922.

(museum, gallery, etc.) as a way of focussing our aesthetic concern and as a means for determining what is art, what then becomes our operative frame of reference for doing so?

And how do we, or can we, now develop a *non*-hierarchical order?

Certainly, if we are seriously to consider extending the boundaries of art, as nonobjective art would have us do, then these are a sampling of the kind of questions handed down by the abstract expressionists that are the legacy for my generation. If we fail to live up to the opportunity they afford, then the whole enterprise of "modern art" can slip back (as it is threatening to do) to its lowest common denominator – individual indulgence pawned off as self-expression.

But enough of all this social talk. Back to work. While on the one hand, everything has the potential to be seen as a sign or a metaphor (a cloud = rain, or a bunny rabbit); on the other hand, everything can be seen in its immediate physicality (a cloud *is* – even before we name it or assign it significance). Both approaches are real; the differences in our understanding lie not in the nature of things, but in how we come to grasp them. While the objective realm of "signs" allows for a properly conditioned "mark" to be repeated sans experience,

⎸

(One) repeated is the power (stands for) (One).

⎸

In the nonobjective realm of physicality, the "mark's" being is nontransferable. **To know** *its* **actuality requires our immediate presence, which in effect puts individual experience at the root of our understanding.** Thus, in modern art, the mark

⎸

repeated is not the same.

⎸

This is a third principle of nonobjective art.

It is a cruel irony of pictorial art that the humanity intended by artists employing the human figure to represent their concerns has

over the long run been subverted by those abstractions inherent in the deep structures of pictorial logic, as they've been played out in fulfilling *its* most basic aspirations. And while nonobjective art was in the beginning cast as the villain by those naïve enough to equate humanity with the human figure, if anything, the opposite is true. The principal contribution of nonobjective art comes in its replacing the *abstracted figure* with the presence of the specific *individual observer* acting directly in determining all matters of quality in art (and in life?).

In Western thought, the search for the quantitative *in everything* has come to affect every facet of our understanding. As a consequence, we seldom trust our "feeling" in matters of "importance," and we pass over the wonders of our seeing for one practicality or another. But a nonobjective, phenomenal art *is* about seeing — about seeing, "feeling," and determining aesthetically. Yet it seems every time we get a real glimpse of this power of *our* seeing, we quickly give it away by attributing to it someone or something outside ourselves. We act as if we've seen a mirage or had a visitation; we make a mystique or a religion of it, instead of accepting the responsibility for what it is — that *we* perceive. It doesn't just happen to us — we make it happen, we participate directly in the forming of that envelope of the world and our being it, and we do so at every moment of our lives. There is nothing more real, more interesting, more powerful, more informative, more important, or more beautiful.

We have now generated a matrix of principles for nonobjective art. They might be recast as follows:

Quantities are no more real than qualities
Intellect is no more true than feelings
Truth is no greater an aspiration than beauty

We can now state the simple facts of our case. Our object-mark,

as phenomenally perceived, has perceptible energies as well as specific physical and dimensional properties. Further, everything true of the "mark" is equally true of that so-called

"empty space" surrounding it. Here in the phenomenal realm we can no longer say that one is more real than the other. Consequently, this "mark" |

no longer rises out of its "ground" as before, but remains an integral part of, and interacts with, its circumstances. To quote Meleau Ponty on this point, "Our visual field is not neatly cut out of our objective world, and is not a fragment with sharp edges like a landscape framed by a window. We see as far as our hold on things extends. Far beyond the zone of clear vision and even behind us." You might say, with Cummings, that in the phenomenal realm, $2 + 2$ never equals less than 5.

Now, if I should try to place a frame around this "mark" [|]

as before, all I will add is another set of physical dimensions. More complex, certainly. More interesting, maybe. But, no more or less real. And when this frame casts a shadow, [|]

as in the case of paintings, what then? Aren't we now confronted by a quality of "thing" that not only has no "meaning," but no corporal reality either? This shadow, in strictly objective terms, is a non-thing. That is, it has no actual physical dimensions. Are you tempted to say that we have gone too far, that this is turning into some mystical-twistical argument intended to confuse the real issues? Still and all, it is right there before our eyes. Can we just simply dismiss it as before? And if there really were no shadows, what then? Would nothing of value be lost? (Actually we could not see as we do without shadows.) Let me say that it is here, in the presence of the shadow, that the phenomenal makes itself known.

Since this is a critical point of our discussion, let me give you an added example of the presence of the phenomenal in our everyday lives. Picture a wall before you. This wall is curved, rough, and red. A cloud passes before the sun and the wall becomes flat, smooth, and violet. Now I can walk along the wall and reaffirm its being curved, and I can run my hands over its surface to reaffirm its roughness. But what am I to do about the violet? Is the violet not real? And what happens to my sense of reality when the wall just

as suddenly turns back to being red, or is influenced into becoming some other color? Do such infinite subtleties constitute a gain or a loss? Are you struck by the wonder of it all – or put off by such impermanence?

What it would seem we now have, returning to the lean aphoristic imperative of Mondrian with which we began this section, are two separate and distinct perceptual realms:

1. *The pictorial:* Here the world of our perception is made up of positives ("particular form") and negatives, continually allowing for a beginning and end.
2. *The phenomenal:* Here the world of our perception is made up of a series of positives (no negatives) in constant "determined relation" with no beginning or end.

Stated in this way and fundamentally juxtaposed like this, these two perceptual realms reveal two distinct and separate value structures.

1.	2.
permanence	change
pictorial	phenomenal
transcendence (systems)	individual (process)
quantities	qualities
truth as knowledge	*beauty as knowledge*

And displayed like this, we *now* come to comprehend the fundamental "meaning" of modern art, for while the first category can be subsumed to the second, the opposite can never be the case.

Conditional

This consequence brings us, in a future perhaps remote, towards the end of art as a thing separated from our surrounding environment, which is the actual plastic reality. But this end is at the same time a new beginning. Art will not only continue but will realize itself more and more. By the unification of architecture, sculpture and painting, a new plastic reality will be created. Painting and sculpture will not manifest themselves as separate objects, nor as "mural art" which destroys architecture itself, nor as "applied" art, but being purely constructive will aid the creation of a surrounding not merely utilitarian or rational but also pure and complete in its beauty.
– Piet Mondrian

What would an art of the phenomenal, of plastic reality, be like? Where and how would it exist, and how would we come to know it?

To try and answer these questions, let's review what we've already established. First, we have already determined that, in one sense, the phenomenal can be located in the dynamics of change in the world; and that, in another sense, it can be located in the dynamics of our perceiving of that world. We can now venture to put these two senses together and say that the phenomenal, as we can know it, exists in the dynamics of our perceiving (experiencing) the nature of the world about us and of our being in it. From this we can infer that the grounds of a phenomenal art will be in *being and circumstance*; and from this we can further infer, as a working principle, that a phenomenal art will be a *conditional art action*. It should be noted that for any such action to be truly conditional, the art act can only occur *in response* to a set of specifics: since a conditional art, by its own definition, possesses no transcendent criteria (truths), it can have no grounds for predetermining (preplanning) its actions. It takes a peculiar kind of compounded belief to plan, proselytize, or thrust your abstractions onto the world. (It is one thing to believe in or desire such concepts as a timeless art, an orderly universe, or a God in the heavens, and something altogether different to act as if these concepts were in fact real, actual, and already at hand.) By contrast, to act *in response* in actively "determining relations" constitutes the ethic of a phenomenal art.

Second, we have also already determined that qualities are the property of the perceiving individual, that warm-cool, hard-soft, red-blue are feelings (not values — we give them value by attending to them). This is what Malevich meant when he declared his "desert" to be filled with pure "feeling." We have stated that the meaning of "modern art" arose when it declared creative art to be a quality-centered discipline; its method to be involvement, not explicit detachment; and that, basically, *art is knowing in action.* The consequence of this, by definition, is that what holds true for the artist/perceiver must hold true for the observer/perceiver. Aesthetics then is not a conceptualized ideal, science, or a discipline, but a method, a particularized kind or state of awareness. The subject/activity of aesthetics, therefore, is feeling (to try and speak of an ideal or a science of feeling is a contradiction in terms) with an "eye" for the special (beauty). Let me again paraphrase Michael Polyani on this point. We cannot learn to keep our balance on a bicycle by trying to follow an explicit rule, such as that to compensate for an imbalance; we must force our bicycle into a curve — away from the direction of imbalance — whose radius is proportional to the square of the bicycle's velocity over the angle of imbalance. But the art of riding a bicycle, of course, presupposes that all of this be understood, be dwelt in — through a personal act of tacit integration.

It is important to note that this metaphor cuts both ways. It has become fashionable to claim that the history of the individual's role in modern art now simply provides a license to mindlessly ride the bicycle, that is, "to express oneself." But in that case, what is *not* an expression? Anything and everything we do, or don't do, is an expression of one kind or another, and what's more they must be thought of as equivalent expressions (the first step toward Nihilism?) unless something else, something more important, is brought to bear. So it is quite clear that "expression" is not a real issue, but simply the lowest common denominator arising from modern art's placing the individual at the crux of the decision-making process.

We have now, in effect, reduced those hoary philosophic issues of change, the phenomenal, and quality down to the conceptual issues of individual, conditionality, and response. What now remains for us to accomplish is to convert these new concepts into

specifics, and we can begin to do this by properly conditioning them. That is, we must provide the operative frame of reference (what it is we measure with, or by) for determining what we can know (and accomplish) from a phenomenal perspective. Consider another example in this context: the universal time becomes 4 a.m. when we condition it with an objective logic (system), i.e., clock time. But it is seasonal when we reference nature, and fleeting when we "tell time" from the perspective of our feelings. To focus the conditions for a phenomenal perspective (art), let us now try laying out, in order, what we have established:

change . . . phenomenal . . . qualities \longrightarrow the perceiving individual

individual . . . conditionality . . . in response \longrightarrow being and circumstance (the operative frame of reference)

being and circumstance . . . determined relations (art as knowing in action) \longrightarrow a phenomenal/conditional art

What takes place from this point forward becomes a horse of a different color. The questions as to *how* we might practice a phenomenal/conditional art and what kind of conclusions (reality) we might draw from this perspective remain to be realized. There are already a number of good artists beginning to test facets of this perspective, each with a unique contribution to make toward a rounded whole that will ultimately become a collective definition of art for our moment in time.

What now follows are my present speculations, ideas, positions, and actions in this regard. I am trying them on to see how they fit (work), what makes *sense* to me, and how I might turn that sense into something (art?) I can live with.

Intention: The intention (ambition?) of a phenomenal art is simply the gift of seeing a little more today than you did yesterday. This intention is based on the simple intuition (truth?) that everything there is to know is not already known. This in turn distinguishes the *subject of art* from the *objects of art* and indicates the fundamental role of art (as in every primary discipline) vis-à-vis the *discipline and practice of art*. **The subject of art is the human potential for an aesthetic awareness (perspective).** The object of

art is a re-presentation of that acquired sensibility (an art object) – a transformation in all dimensions of what was previously known otherwise into an objective form. The *action (practice) of art* carries this sensibility to become a part of all our individual, social, and cultural values (systems, institutions, etc.).

Sculpture: For this term to remain useful, it must be expanded to indicate (mean) the articulation of three and four (even five?) dimensional space, in terms of being, place, ("determined") relations, and order, as well as form.

Site conditioned/determined sculpture – as distinguished from the generic term "public art" (which permits everything not nailed down to be thrown into one pot, as in a teeming bouillabaisse) – is an attempt to integrate the components of the phenomenal, conditionality, and response with the practical goal of bringing modern art's focusing of qualities (beauty) to bear directly on how we order our world. Mondrian's words bear repeating on this point: We are attempting "to aid in the creation of a surrounding not merely utilitarian or rational but also pure and complete in its beauty."

To help sort out some of the confusion of ambitions and practices, let me rough out some general working categories for public/site art, in terms of how we generally process (recognize, understand) them. (Note: there are no value judgments intended here, only distinctions.) Put simply, we can say that any given work falls into one of the following four categories:

1. *Site dominant.* This work embodies the classical tenets of permanence, transcendent and historical content, meaning, purpose; the art-object either rises out of, or is the occasion for, its "ordinary" circumstances – monuments, historical figures, murals, etc. These "works of art" are recognized, understood, and evaluated by referencing their content, purpose, placement, familiar form, materials, techniques, skills, etc. A Henry Moore would be an example of site dominant art.

2. *Site adjusted.* Such work compensates for the modern development of the levels of meaning-content having been reduced to terrestrial dimensions (even abstraction). Here consideration is given to adjustments of scale, appropriateness, placement, etc. But

the "work of art" is still either made or conceived in the studio and transported to, or assembled on, the site. These works are, sometimes, still referenced by the familiarity of "content and placement" (centered, or on a pedestal, etc.), but there is now a developing emphasis on referencing the oeuvre of the individual artist. Here, a Mark di Suvero would be an example.

3. *Site Specific.* Here the "sculpture" is conceived with the site in mind; the site sets the parameters and is, in part, the reason for the sculpture. This process takes the initial step towards sculpture's being integrated into its surroundings. But our process of recognition and understanding of the "work of art" is still keyed (referenced) to the oeuvre of the artist. Familiarity with his or her history, lineage, art intent, style, materials, techniques, etc., are presupposed; thus, for example, a Richard Serra is always recognizable as, first and foremost, a Richard Serra.

4. *Site conditioned/determined.* Here the sculptural response draws all of its cues (reasons for being) from its surroundings. This requires the process *to begin* with an intimate, hands-on reading of the site. This means sitting, watching, and walking through the site, the surrounding areas (where you will enter from and exit to), the city at large or the countryside. Here there are numerous things to consider; what is the site's relation to applied and implied schemes of organization and systems of order, relation, architecture, uses, distances, sense of scale? For example, are we dealing with New York verticals or big sky Montana? What kinds of natural events affect the site—snow, wind, sun angles, sunrise, water, etc.? What is the physical and people density? the sound and visual density (quiet, next-to-quiet, or busy)? What are the qualities of surface, sound, movement, light, etc.? What are the qualities of detail, levels of finish, craft? What are the histories of prior and current uses, present desires, etc.? A quiet distillation of all of this—while directly experiencing the site—determines all the facets of the "sculptural response": aesthetic sensibility, levels and kinds of physicality, gesture, dimensions, materials, kind and level of finish, details, etc.; whether the response should be monumental or ephemeral, aggressive or gentle, useful or useless, sculptural, architectural, or simply the planting of a tree, or maybe even doing nothing at all.

Here, with this fourth category of site-conditioned art, the process of recognition and understanding breaks with the conventions of abstract referencing of content, historical lineage, oeuvre of the artist, style, etc., implicit in the other three categories, and crosses the conventional boundaries of art vis-à-vis architecture, landscape, city planning, utility, and so forth, reducing *such quantitative* recognitions (measures and categories) to a secondary importance. We now propose to follow the principles of phenomenal, conditional, and responsive art by placing the individual observer in context, at the crux of the determining process, insisting that he or she use all the same (immediate) cues the artist used in forming the art-response to form his or her operative-response (judgments): "Does this 'piece,' 'situation,' or 'space,' make sense? Is it more interesting, more beautiful? How do I feel about it? And what does it mean to me?" Earlier, I made the point that you cannot correctly call anything either free or creative if the individual does not, at least in part, determine his or her own meaning. What applied to the artist now applies to the observer. And in this responsibility of the individual observer we can see the first social implication of a phenomenal art.

Being and circumstance, then, constitute the operative frame of reference for an extended (phenomenal) art activity, which becomes a process of reasoning between our mediated culture (being) and our immediate presence (circumstance). *Being* embodies in you the observer, participant, or user, your complete genetic, cultural, and personal histories as "subsidiary" cues bearing on your "focal" attending (experiencing) of your circumstances, again in a "from-to relation." *Circumstance*, of course, encompasses all of the conditions, qualities, and consequences making up the real context of your being *in* the world. There is embedded in any set of circumstances and your being in them the dynamic of a past and future, what was, how it came to be, what it is, and what it may come to be.

If all of this seems a bit familiar, it should. No one "invents" a new perceptual consciousness. This process of being and circumstance is our most basic perceptual (experiencing) action, something we already do at every moment in simply coming to know the nature of our presence, and we almost always do so without giving the wonder of it a second thought. Once again this "over-

sight" speaks not of its insignificance; on the contrary, it speaks of its extraordinary sophistication. What I am advocating is simply elevating this process, this reasoning, to a role of importance that matches its innate sophistication. It should be noted that it is upon this "reasoning" process that all of our subsequent logics (systems) are instinctively patterned – although this generally goes unacknowledged. But with one modification (gain and loss): to cut the world down to a manageable size, our logics hold their components to act as a kind of truth, locking them in as a matter of style into a form of *permanence*. Conversely, the process of reasoning, our being and circumstance (which I am here proposing), is free of such abstraction and can account for that most basic condition (physic) of the universe – *change*.

The wonder of it all is that what looked for all the world like a diminishing horizon – the art-object's becoming so ephemeral as to threaten to disappear altogether – has, like some marvelous philosophical riddle, turned itself inside out to reveal its opposite. What appeared to be a question of object/non-object has turned out to be a question of seeing and not seeing, of how it is we actually perceive or fail to perceive "things" in their real contexts. Now we are presented and challenged with the infinite, everyday richness of "phenomenal" perception (and the potential for a corresponding "phenomenal art," with none of the customary abstract limitations as to form, place, materials, and so forth) – one which seeks to discover and value the potential for experiencing beauty in everything.

Projects

Preface to Projects

The following descriptions (in conjunction with the fall 1985 exhibition at The Pace Gallery in New York) document some of my initial attempts to practice, in response, a conditional art. Seen individually and in context, these responses were of course initially intended to be experienced as one with their site. Served up like this, collectively and in abstracted form (*through* drawings, models, photographs, etc.), they are merely intended to flesh out the bare bones of our discussion on the whys and wherefores of a phenomenal (site) art. For example, with my work of the last decade presented cheek-to-jowl in this manner, I would seem from any formal, historical, or oeuvre perspective to be careening out of control in some irrational, even eclectic, manner — one time spare, then again rococo, formal and now romantic, architectural and then sculptural, and so forth. But on the contrary, all of this variety only serves to further establish my point — something more fundamental is at stake here: a new and different dynamic is serving as the grounds for my decision-making, for my art.

Now since the world, to this point, is under no obligations to change its values, procedures, or contracts simply to accommodate me (or even to take my proposals seriously), I have to date simply taken my invitations at face value (rather than to try and count the teeth of these gift horses) as an opportunity to work, i.e., to do what I like to do best, to travel the country spending time running my hands over each unique site, and to develop each proposal as if — even though in many cases it is quite clear from the beginning that my proposal will never be realized — each instance offers an occasion for new learning, for in the face of such vast potential, I am continually beginning all over again.

For all of the artists who have been participating in them, projects such as these are riddled with contradictions, risks, failures, successes, and even a kind of black humor. The stories are becoming legion.

Wellesley College

Exhibition: Site Works

Sponsor:
Jewett Arts Center, Wellesley
Curator: Judith Hoos Fox
Artists: Antonakos, Holt, Smyth, Irwin

Project Initiated: August 1979

First Site Visit: September 1979
Very romantic, idyllic college campus. Old,
comfortable architecture, except for the surprise of
the new science center. Nature is queen here –
rolling planes of grass, strong dark-light patterns
cast by old established trees, a beautifully situated
lake – the whole place has a gentle charm and does
not need much from me.

Project Proposal: November 1979 – "Filigreed Line"

Project Upgraded: December 1979
Additional money to make project permanent from
Lois Patterson de Menil and Millie Glimcher
(Wellesley Alumnae).

Project Completed: May 1980
Fabrication: Jack Brogan, Ryerson Steel

Materials: ³/₈" stainless steel, pattern plasma cut,
concrete footings

Project Photography:
Finished project: 3 seasons
Details: Judith Hoos Fox

1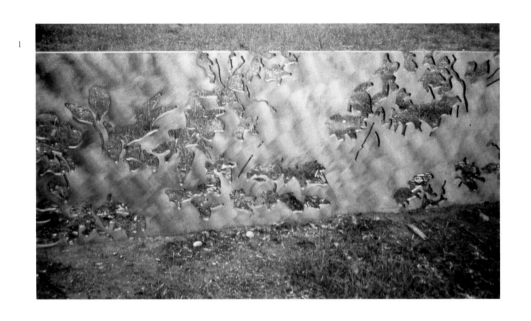

2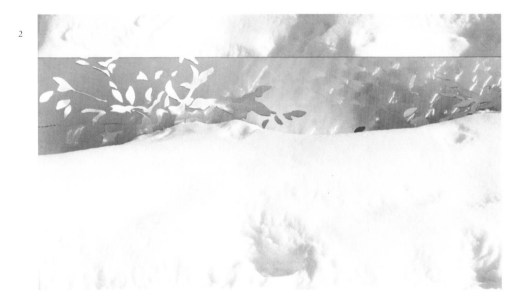

The project began as a piece of a collaborative effort on the part of five museums in the Boston area – Brockton, Danforth, DeCondova, the National Center for Afro-American Artists, Rose-Brandeis University – and the Jewett-Wellesley College.

On my first visit I was struck by the grace of the nature on the campus. How beautiful it all was, and without any intrusion from me. I was struck as well by the challenge made on our claims of "beauty" in art – a challenge that "art" on the whole has avoided by remaining insular, protected by its intellection of the object and frame. The challenge to interact, work directly with nature, has always been a latent question in art, a question brought into focus in "modern art" by the implication inherent in the edict to effect a "marriage of figure and ground." I find it odd that we come to honor the art of artists who author such "concepts" and then don't test the concepts or let them change our lives. I consider such "honoring" meaningless. Such a neglect turns art into decoration.

What would it actually be like to act out "the marriage of figure and ground" in the world?

My proposal "Filigreed Line" was a line of stainless steel running along a ridge of grass and in front of the lake. It is low in profile, only a few inches high in some places and never more than 2' at any point. A pattern of leaflike shapes, taken from leaves on the site, is cut through the steel, creating a light, open feeling which is accentuated by a pattern cut onto the surface of the steel. This pattern causes the line, at times, to become lost in the pattern of light on the lake (and in the winter on the snow), to dance along the ridge, coming and going. My best hope for the "line" is simply that it refocus the too-often habituated eye of the passerby to the qualities and pleasures in his or her immediate environment.

1 *Detail:* Summer
2 *Detail:* Winter
3 *Project Elevation,*
 Autumn (overleaf)

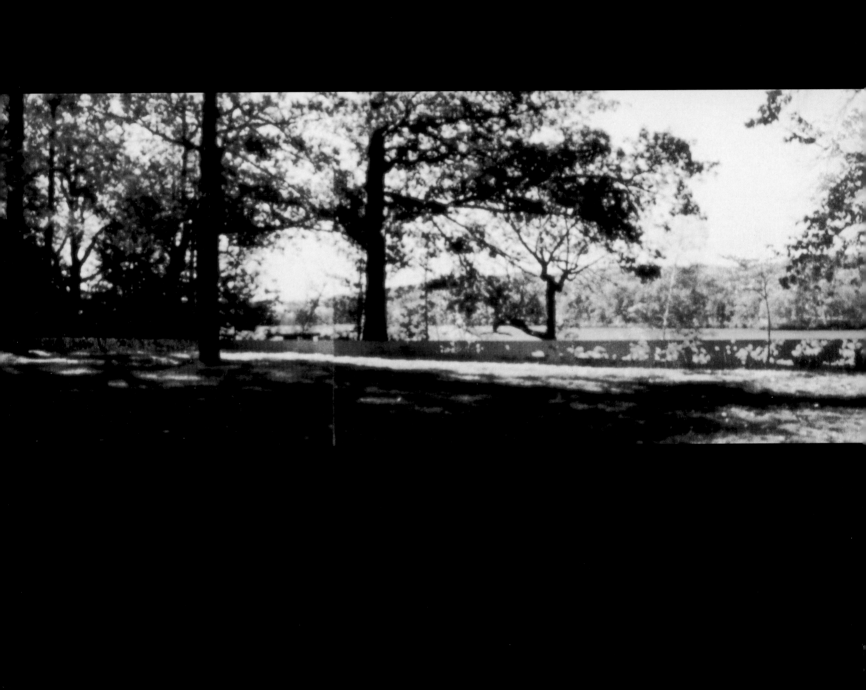

Ohio State University

Project Site: University Campus

Competition:
Sponsor: University Art Gallery
Director: Betty Collings
Artists Selected:
Robert Morris, Richard Serra, Tony Smith, R. Irwin

Project Initiated: September 1978

First Site Visit: October 1978
Site selected: the "Oval Mall," the active focal
point of the campus, its most distinguished place.
A nice natural confrontation brought on by the
real complexity of criss-crossing paths. The Oval
has great scale and presence. Yet, while it is obvi-
ously an important symbol and meeting place, little
attention seems to have been given to this fact. All
its "success" as a place seems more fortuitous
than considered.

Project Proposal: December 1978 – "Tilted Planes"

Project Selected: January 1979 – Sculptural
Advisory Panel

Developed Proposal: Submitted March 1979
Engineering: Stephen Mulschenbacher
Site Survey: Campus Architect's Office

Materials: Cor-Ten steel, concrete footings,
re-sod grass

Project Status: Project died in the Dean's office. It
was never seriously considered and no explanation
was given – although the Dean later tried to buy a
Tony Smith "sculpture."

Project Photography:
Model: Susie Einstein
Campus Aerial: stock shot

4

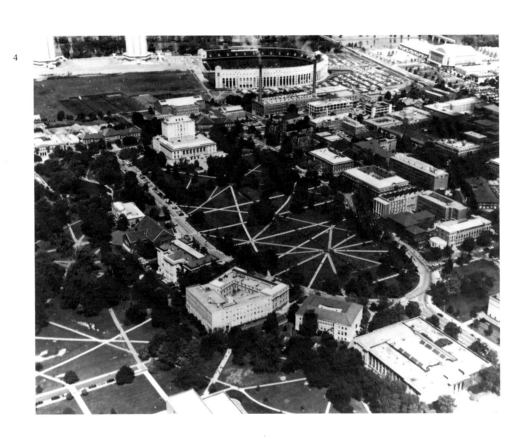

The site I selected, while far from a classic mall design (not what Jefferson had in mind), nevertheless has the proper scale and character befitting its place—a large-populous, Midwest university. While the architecture surrounding and defining the "Oval" is a pastiche of time, style, and material, the sum total allows for a really comfortable sense of place. And while the initial layout of its crossing paths and resulting planes of grass may have had a formal geometry in mind, with the passage of time students have walked in an overlapping informal geometry which now provides the Oval Mall, like the architecture, with a richness of variety and surprise.

Now, add to these givens the fact that every hour, on the hour, of the school day the Oval is flooded with a rush of students criss-crossing the paths—so many paths, so many people, going in so many directions that their crossings seem to lose all "rhyme or reason"—and the entire Oval takes on the spatial-temporal qualities of a serious existential landscape.

My proposal "Tilted Planes" was intended to act in concert with these "given" phenomena. Because of the scale and the ever-so-slight "bowl" of the Oval, the different sections of grass, triangles, etc., take on the optical illusion of rising and tilting. My proposal would simply activate to a level of subliminal cognizance what is already present and thereby "mark" the Oval as a special place, without changing its basic historical configuration. Secondarily, my plan creates a focus on those key "meeting" places and provides the incidental seating needed on the edge of the raised grass—which is now missing—and it does so without the addition of cumbersome street furniture.

This, it seemed to me, would have been a perfectly integrated figure/ground sculpture. The Dean's question, "Where's the sculpture?" proves my point.

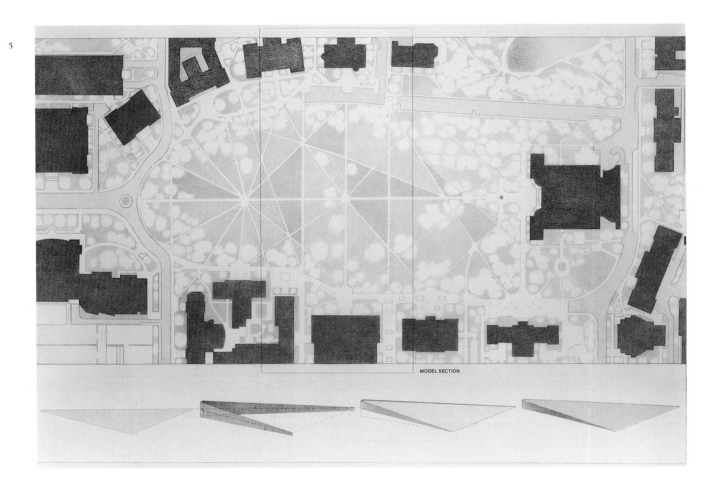

MODEL SECTION

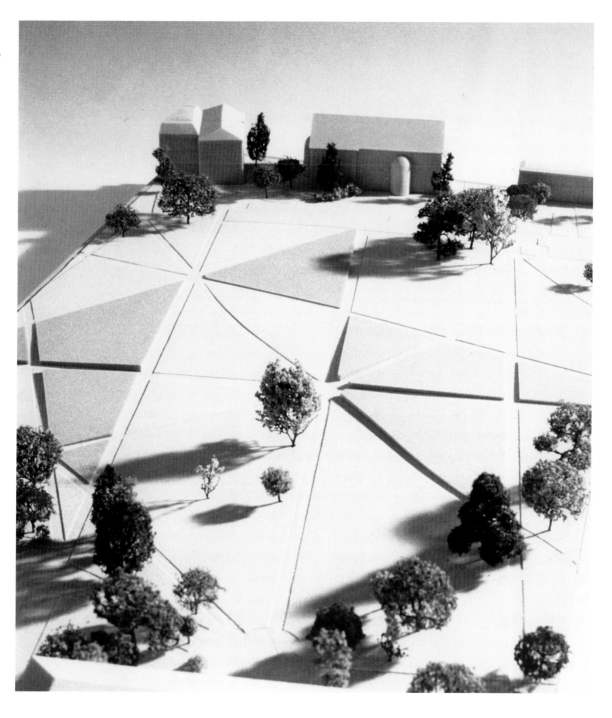

Lincoln, Nebraska

Project Site: 13th and "O" Streets

Sponsor: City of Lincoln, Mayor Helen Boosalis
N.E.A. Art in Public Places

Project Initiated: October 1979

Selection: National Endowment Panel
Mayor's Sculpture Committee

Note: N.E.A. Panel originally rejected the Mayor's
site (13th and "O" Streets) as being too restricted
to one corner (N.B.C. Bank) so that the project
might not appear public enough.

First Site Visit: December 1979
The intersection of 13th and "O" Streets constitutes
the main corner of Lincoln and "O" Street, the
main drag (it was formally the main east-west
highway). The four corners have disparate
architecture, both in style and scale: Miller and
Paine, a nice well-proportioned building; J.C.
Penneys, a throwaway; Walgreens, nice but
insignificant. The intersection is clearly dominated
by the N.B.C. Bank building. It also provides, as the
N.E.A. noted, the only open space. The problem is,
it's clumsy in its proportions and the open space is
poorly scaled – on the plus side, it is a void badly in
need of something.

First Proposal: February 1980 – "Formal Crossing"

Materials: Tri-Ten High Strength Steel, DuPont
"Emeron" 2-part urethane paint

Project Status: Rejected by Federal Highway
Commissioner Ray Hogrefe – April 1980

Second Site Visit: September 1980

Second Project Proposal: November 1980 –
"Second Crossing"

7

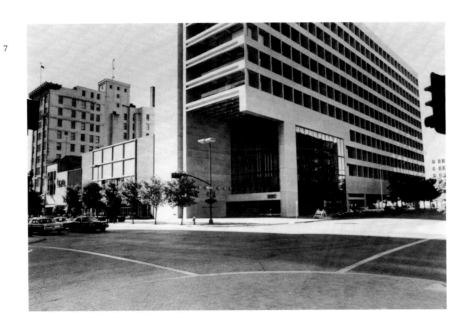

8

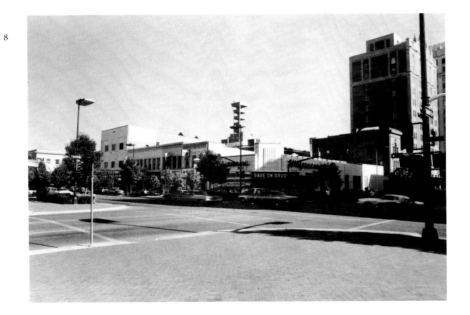

Materials: Cast concrete, 12″ 18″ 21″ schedual #40
stainless steel pipe

Project Status: Rejected by N.B.C. Bank's architect,
James Lingo Fried

Project Photography:
Site: Stock shots
Model: Gordon Summers

The insistence by Mayor Boosalis that the project should happen in the main intersection of Lincoln, Nebraska, was in fact a commitment to the very spirit of so-called "public art" — that it directly affect the quality of the places we live in. Most "public art" is only marginally public; generally it is consigned to an out-of-the-way place, a leftover cul-du-sac, or a "ceremonial spot" of the architect's choosing. The motives for such projects are often too simply an afterthought, usually a day-late and a dollar-short, a quick fix for a project gone sour. The artist's entree is limited to an "artistic" but discreet gesture.

The problems confronting real-public projects are legion. To begin with, such visibility brings out of the woodwork everyone with an "I know what I like" opinion. On the whole, this public hates change (the irony is that fifty years later they will be fiercely defending *as theirs* what originally they so fiercely fought against). The committees thrust in the breech between the public and public officials are typically confused, powerless, and too often incompetent, only muddying the water with their "good deeds." The bureaucrat simply does not want the "mess" to stick to him; while the man at the top, not having a working consensus and confronted by something he doesn't fully comprehend, runs scared. All of which results in a mandate for the functionary who just loves to throw his wrench in the works and exhibit his power by issuing edicts drawn on his simple, but easily-understood, quantitative value system, i.e., "It ain't safe," "It's in the way," "I can't sweep around it," "It can't be done." This, in turn, gets all of the

above off the hook with their "good" consciences still intact.

The fact is, "public art" projects most often fail for the lack of any clear understanding of the actual social value of art—an understanding capable of generating an appreciation of the worth of *qualities* in our lives in a world otherwise governed by the simpler pragmatics of quantities as the measure of worth.

My first proposal, "Formal Crossing," was a geometric progression in scale and form, in three parts, cutting diagonally across the intersection of 13th and "O" Streets. The largest section was to stand in the void in front of the bank, with an extended section that steps to the curb. The center (T-shaped) section was to stand in the middle of the intersection, tying the "crossing" to the third and smallest section in front of Walgreens as a continuation of their form. The three sections were to carry a "crossing" overhead band of steel (with two breaks) which would create an "underpass" for both pedestrians and auto traffic travelling along both 13th and "O." The standing sections of the sculpture were to be painted black, with two red accents, while the overhead band was to be painted white.

This proposal was eventually killed in a public debate with a functionary from the federal highway office. I pretty much rebutted each of his practical minded arguments, but he rested his case on the authority of his office.

My second proposal, "Second Crossing," was a linear structure in stainless steel (which would have enabled me to accomplish the "crossing" of the street without the center section), consisting of two arms (crossings), each extending at right angles from the main section set in the void in front of the bank, one crossing 13th Street and one crossing "O" Street.

The project was eventually killed by the bank's lead architect, James Lingo Fried, who preferred his void.

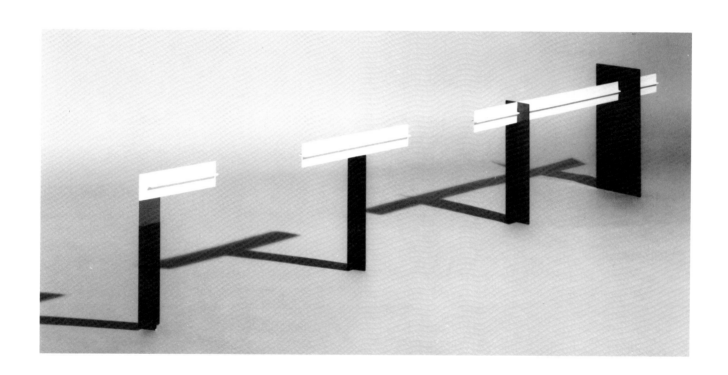

Cincinnati

Project Site: Fountain Square Atrium

Sponsor:
Ad Hoc Arts Committee: Chair., Robert Sterns,
Ruth Meyers, John W. Galbreath & Company

Project Initiated: August 1981

First Site Visit: October 1981
The Atrium space is open, very light, and
anonymous. It's a kind of no-man's land; the back
door for the offices, bank, hotel. It not only lacks a
focus, it seems to lack a reason for being. Its
physical placement and relation to its namesake
and supposed *raison d'être* – Fountain Square, an
unusually successful public space – is very
unfortunate. It's the resultant isolation of the atrium
that is being contested and which, in turn, has
become the reason for this "Arts Project." This
problem could have been resolved in a more
imaginative way if I had been involved from the
beginning. But, in retrospect, and under the gun,
it's a limited opportunity.

Project Proposal: March 10, 1983 –
"Garland Wreath"

Materials:
Support Columns: sunset red granite
Ring: Stainless steel, green plastic liner, water
pumps and recovery system

Project Status: Application to N.E.A. Arts in Public
Places to fund $50,000 of the proposed $400,000 +
budget was turned down. This has, in effect, dis-
couraged an insecure group of people. The project
is in limbo.

Project Photography:
Site: stock prints
Composites: R. Irwin
Model: Portogallo, Gordon Summers

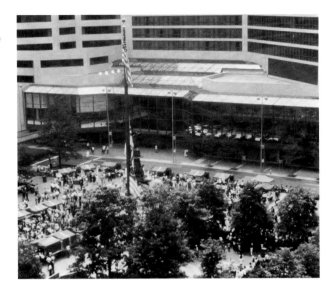

10

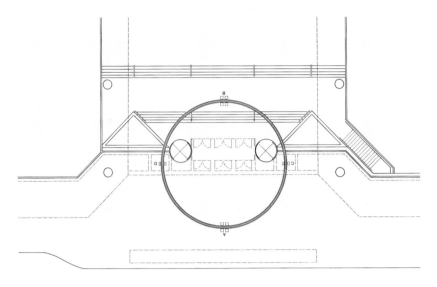

11

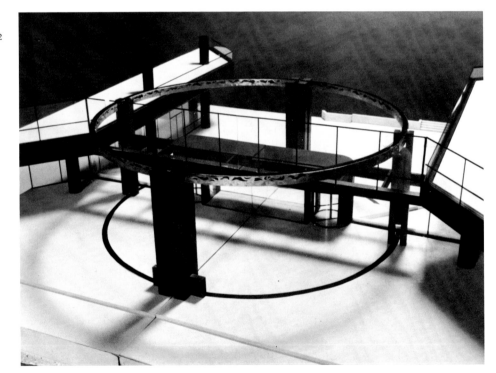

12

This project was conceived as a possible solution to an impass in a contested site, Fountain Square Atrium (a supposedly public space in a major office-hotel-retail development bordering the north edge of Fountain Square). A claim has been made by some people in Cincinnati, if not of impropriety, certainly of insensitivity in the design and use of the Atrium space. The city and the developer were, at best, reluctant partners to an invitation initiated by the director of the Contemporary Arts Center, who requested that I and the very good architect-designer Michael Graves be asked to develop proposals. Graves later dropped out for reasons of his own, probably because he's smarter than I am.

A surprisingly high percentage of public projects begin under similar circumstances: the artist brought in late as "alchemist" to solve social, architectural, or utilitarian omissions; the invitation most often extended with skepticism by the practical-minded. To quote the hotel manager in this instance, "Of course we want art, but we are concerned that you don't interfere with the annual Christmas decorations." My response to the site, "A Garland Wreath," was to tie the isolated interior Atrium space into the exterior public space physically as well as thematically, to give the Atrium an entrance with an identity and gesture of unity with its parent space, Fountain Square.

A ring of filigreed stainless steel and running water, begins on the walk outside the Atrium entrance, supported by a 20' high red-granite sculptural form, and circles around in both directions to penetrate the glass of the Atrium façade at two points approximately 45' apart, supported on each side by a smaller granite form, which also penetrates the glass of the façade, this time vertically through a stepped overhang in the façade. A second large red-granite sculptural form stands on the first landing of the steps down inside the Atrium and receives the completed ring of steel. Here and outside in its counterpart, the water flowing in the ring falls between the four legs of the granite form and into a pool at their base. At night, the interior of the ring and the water are lit by the glow of a pale green light which reads through the filigree pattern cut through the steel. Note: all this could be accomplished without displacing a single Christmas bauble.

In a project of this kind, there are questions which beg to be asked. For instance: What, if any, are the differences here between

simple problem-solving (designing) and my claim for a "creative response?" How are my actions any different from that of a designer? And is design an art form? Are architect-designers artists as many claim? And if architects are artists, by the same reasoning, are artists architects? Is one tempted to join the "isolationism" of a Clement Greenberg and declare that when art crosses the boundaries of painting and object, it simply becomes something else? But isn't this a little too simplistic? Whatever happened to the more complex questions of quality and intention for determining what is art? Yet, if we fail to honor any such boundaries, are we not courting a kind of chaos in our understanding? Did Aristotle give us good guidance in such matters when he declared qualities to be accidents and threw them out of philosophy all together? What is your opinion of those who are content to let Skinner's behaviorism settle the issues of individual intentions? And how would you respond if I were to insist (as I have) that these issues of quality and individual intention are at the heart of the meaning of modern art?

13 *Model (section):*
 "Garland Wreath"

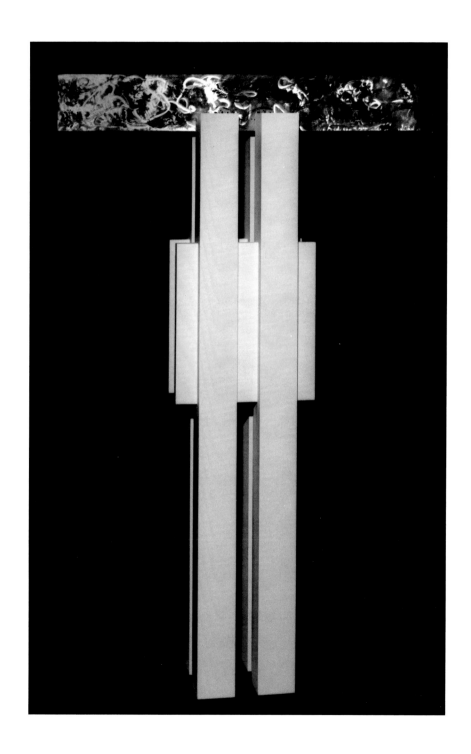

San Francisco

Project Site: International Airport Terminal

Sponsor:
Airport Arts Commission
San Francisco City Arts Commission

Project Initiated: July 1982

First Site Visit: October 1982
Site consists of two large openings cut between the
first and second floors at the entrance-exit of the
original airport building, now being refurbished
and expanded as the airport's international
terminal. This is a very complex site, both visually
and logistically. Whatever is proposed needs to
"work" from a radical variety of perspectives and
physical conditions. For example, the normal
"viewer" will pass through the site only in leaving
from the second floor or arriving on the first floor,
so that the proposal will need to "work"
independently on each floor (and from each side).
You can look down on it or up at it, but you can
never see the whole from any normal profile view.
Add to this the heavy pedestrian traffic, no
maintenance to speak of, and an overwhelming,
overhanging glass-and-steel canopy, and you have
the ingredients of a very challenging site.

Project Proposal: December 1982 – "Two
Ceremonial Gates, Asian Pacific Basin"

Project Completed: July 1983
Engineering: Dennis Oh
Fabrication: Jack Brogan, Ryerson Steel Company

Materials: Steel, box, tube and plate
Two-part DuPont Emeron paint finish, black and
white #2, 1-ton Natural Mexican Onyx rocks

Project Photography:
Site: Robert Irwin
Project: Malcolm Lubliner
Model: Gordon Summers

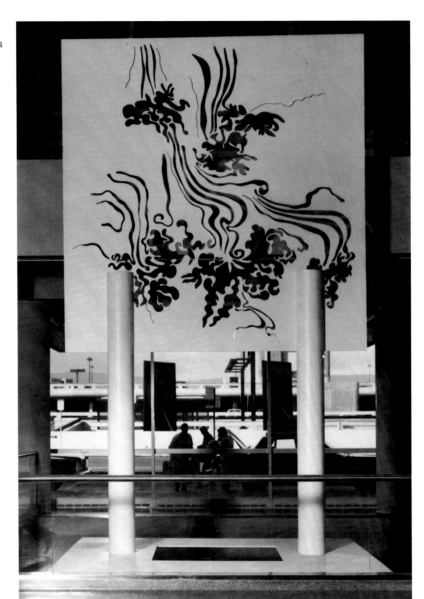

This was a complicated project: short on money, short on time, a demanding site, a truncated development process, a naïve "arts" committee, and an incompetent "arts" commission. To all of this was added a required (not negotiated) contract which protected the city from, and obligated me for, everything—and after which I was literally thrown to the wolves. For example, because the "arts" commission and the committee had not done their homework in preparing the project, the prime contractor for the construction site was in no way obligated to cooperate with me or even let the artists onto the site. At one point, to make me the scapegoat for the late penalty clause in *his* contract, I was literally forced to move my entire project—including 15 tons of steel and 4 tons of rock— back out onto the street with nowhere to go. Further, no one had thought to alert or negotiate with the union for a special dispensation for the artists to work on the site. Consequently, the union closed me down, requiring I either join three unions—riggers, welders, and painters—or else hire a "feather bed" union crew to watch me work. Thus, you begin to have a case study in what can go wrong with site (public) art.

Up till now, the artists involved in all the phases of the development of site art have just gritted their teeth, closed their eyes to all the risks, and gone ahead to "make" the projects happen. In this case, at one point, because of the above harassment, I was over $40,000 in debt! I was only saved because a lady knight from the district attorney's office took it upon herself to rescue me.

Our "processes" are not permanent or sacred, nor intended to be bureaucratic security blankets. They are systems designed by us for the sole purpose of gaining our conceptual ends. The first overt indication of a change in our conceptual intentions is always found in the developing necessity to get our operative "processes" in line with our new conceptual needs.

Our present "processes" were set up to facilitate a studio-object which basically requires only a two-stage development: the identification of a site, and the selection of an artist-object. In this "commission" relationship, the "patron" makes the crucial site decisions as to where, what, and who is appropriate.

But the idea of taking site art beyond site-specific to site-generated is radical enough in its implications to require a review of all of our processes. The implications of the "marriage of figure and

14 *Detail:* "Two Ceremonial Gates,"
 Asian Pacific Basin

ground" in this new "site art" require a more intimate hands-on role for the artist from the very outset, replacing the abstract principles underwriting the portable object. The process for generating valid site art should go as follows: (1) An initial site visit by the artist – preferably before too many commitments have been made. (2) The second step is naturally for the artist to develop a creative response to the various conditions unique to the site-project. Adjunct to this second phase is (3) the presentation of the "idea." This is more complicated than it may first appear. Because of the radical integration of the idea, it requires that the presentation represent not only the specific properties of the response per se, but also their effect – a mood, a feeling, or something merely implied – "things" next to impossible to "represent." This intimacy makes it virtually a requirement of the process that the artist participate in all critical presentations of the "idea." The more lay- or practical-minded the participants are, the more important it is that someone walk them through the idea and point out its potential. Further, since the project will come to fruition in their backyard, you cannot simply dismiss any of their legitimate concerns.

Now if everyone is in general agreement as to the quality of the idea and its general feasibility, a second interim (tentative) commitment can be made by both parties – artist and sponsor. This involves (4) project development. This step was a relatively simple one in the old "commissions" process since the logistics of the studio-object and its placement on the site were, on the whole, already in hand. But in a deeply integrated project, the sponsor for his part must now get all his Indians in a row to support the now-known idea. This requires a review of its supporters, contributors, logisticians, city agencies, unions, safety, maintenance, etc. The artist, for his part, may need a site survey, a review of relevant construction and utilities codes, etc.; he has to virtually engineer the entire proposal. Once all these items are in hand, a working budget and timetable can be projected. At this point, and only at this point, should a binding – for either party – agreement be made.

(5) The contractual agreement should reflect the unique character and special circumstances of the creative "idea" and the appropriate responsibilities for getting it done. So that now, and only now, do we come to (6) construction and installation.

The lesson in this digression, for those who wish to accomplish

a significant site work, is to begin at the beginning—that is, to first examine your language (your prospectus), your procedures, and all your participants (for this is a collaborative effort) to make sure that they match your vision.

Getting back to my proposal for San Francisco, "Two Ceremonial Gates, Asian Pacific Basin" was developed out of the salient conditions of the site. My response to the symmetry of the "Mirror" identical spaces was two structurally identical and symmetrical, but aesthetically opposite, "sculptural" forms: one formal and black, the other floral and white. The bottom of each stands opposite the two Customs exits. At the base of each sculpture is set, like an icon, a large (2-ton), rugged, red-pink onyx rock. From there, the "gates" pass up through the openings in the ceiling to the upper floor, each with two 8' x 12' horizontal 1"-thick steel plates, with a 3' x 5' opening cut in the center, echoing the cut in the plane of the ceiling-floor. The first plate is set at 7' and acts as a ceiling to the "shrine-like" base. The second plate is set at the height of the second-level floor. At the top of each "gate," standing in relief against the light, is a 12'-square pictorial plane. The black plate is cut through with nine small 16" x 16" openings. The white plate is cut through with a flowing-floral pattern.

Or, anyway, that's how it was supposed to be. Late in the project, because of engineering weight concerns, the two "gates" were moved approximately 20' further apart. Unfortunately, this, coupled with the commission's/committee's failure to even light them at all, has rendered their presence in the site peripheral, and their success only marginal.

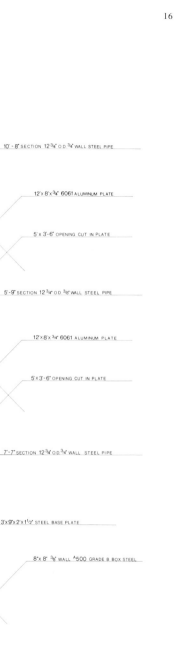

16½"x16½" HOLES (9) CUT/MACHINED IN PLATE

12'x12'x¾" 6061 ALUMINUM PLATE

10'-8" SECTION 12¾" O.D.¾" WALL STEEL PIPE

MECHANICAL FASTENERS / WELD FINISH

12'x8'x¾" 6061 ALUMINUM PLATE

12¾" HOLE MACHINED IN PLATE
PLATE RESTS ON PIPE SECTIONS

5'x 3'-6" OPENING CUT IN PLATE

3' SLEEVE ⅜" WALL MACHINED TO TRUE 12" O.D.

5'-9" SECTION 12¾" O.D.⅜" WALL STEEL PIPE

12'x8'x¾" 6061 ALUMINUM PLATE

12⅜" HOLE MACHINED IN PLATE
PLATE RESTS ON PIPE SECTIONS

5'x 3'-6" OPENING CUT IN PLATE

3' SLEEVE ¾" WALL MACHINED TO TRUE 12" O.D.

7'-7" SECTION 12¾" O.D.¾" WALL STEEL PIPE

⅜" END PLATES

3'x9'x2'x1½" STEEL BASE PLATE

LEVELING ☐TS

8"x8" ⅜" WALL A500 GRADE B BOX STEEL

12¾" O.D. P PE WELDED TO PLATE

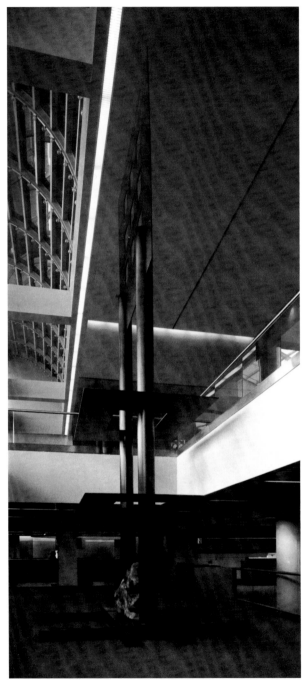

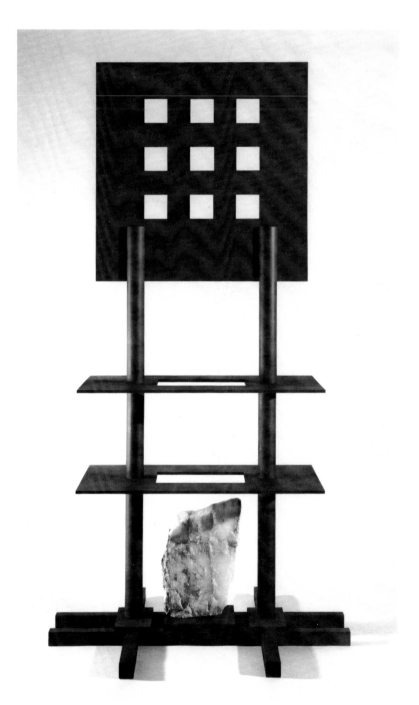

17

15 *Drawing:*
 Construction Explosion
16 *Detail:*
 Side View (Black Section)
17 *Model:*
 Facing View (Black Section)

Seattle

Project Site: Public Safety Building Plaza

Sponsor:
1% for Art, City of Seattle
Mayor: Charles Royer
Seattle Arts Commission: Karen Gates, Richard Andrews
National Endowment for the Arts

Project Initiated: September 1979

First Site Visit: October 1979
This is a very forlorn, isolated, even hostile plaza surrounded by very grey architecture. The only visitors are a few people paying fines or visiting friends in the city jail, which occupies the second and third floors. This site has three disparate vantage points: (1) that of the people passing through, (2) a strong "graphic" read-down from the surrounding office buildings, and (3) a limited visibility from the street. Ideally all three need to be developed. Most importantly, the plaza needs greening.

First Project Proposal: January 1980 – "Three-Ring Maze"

Materials: Rings, cast concrete, grass, asphalt.
Project found not feasible. An old set of engineering drawings suddenly surfaced, indicating the plaza will only support weight at the points of its subsurface columns.

Second Project Proposal: April 1980 – "9 Spaces, 9 Trees"
Engineering: Edwin T. Hudson

Materials:
Planters: cast concrete
Fencing: Kolorgaard $5/8''$ aperture, plastic coated, special-order blue
Trees: Visuvius plum trees
Ground cover: Sedum Oreganium. Refinish black asphalt topping with tennis court surface

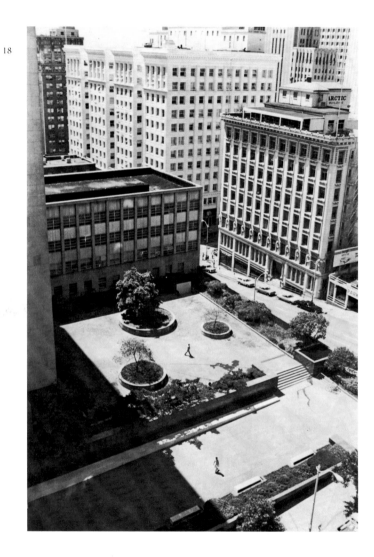

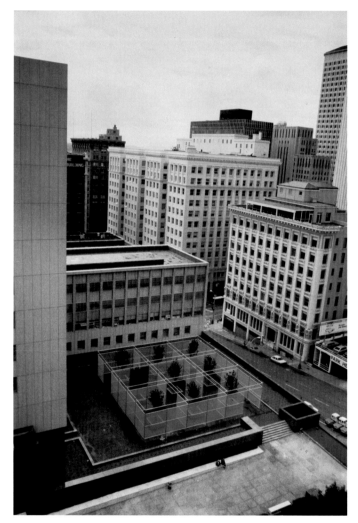

Project Completed: July 1983
Construction: Larry Tate, Gerald McGinnis
Aluminum fencing contributed by Fentron Corp

Project Photography:
Site: B&W stock shots
Project: Richard Andrews, Larry Tate, Ron Carraher

Seattle has a good reputation for its public arts program—a reputation earned by the simple fact of their being prepared enough and committed enough to deal in a professional way with the various proposals submitted by artists in response to the invitation to work in the public spaces of Seattle. This professionalism—as opposed to the surprise, general hysteria, and automatic negative response that most often greets such proposals—has generated an atmosphere that allows artists like myself to test in the public place those tenets of modern art as they may affect the public concern.

It is my supposition that the practice (understanding) of modern art is now far enough advanced to consider directly how its views, values, and ethics might actually affect "real life" circumstances. This idea of mine constitutes a kind of general definition for the "intention" underwriting the present phenomenon of "site art." This as opposed to the generic label of "public art," a view which draws no useful distinctions from past public practices and presently acts as a kind of populist umbrella under which a general chaos prevails. Everything from the classical aspirations of the historical, moralistic, and heroic object-monument, to the do-good social-political utilitarianism and the free-for-all of freeway, wall, and subway graffiti, qualify as being "public." Much of this activity stems from the misconception that the general estrangement that developed between modern art and the general public is due to art having "lost its way," and that the problem is solvable, that is, reversible, through the simple reintroduction of old and familiar art forms and good deeds performed in the public place.

This view is not justified. One needs simply to consider that too many individual artists from too many separate places, with too

many real differences in their backgrounds, values, and motives, were engaged in its practice and definitions for the "history" of modern art to be either accidental or incidental. Furthermore, our world is never that far out of balance. If such "modern" ideas are so prevalent in any one discipline, they should be equally so in others. And, in fact, they are. Modern physics, biology, sociology – in short, all modern thought-philosophies have undergone similar and parallel radical histories.

It is in the view that this so-called "gap" between modern art and the general public, is in fact, a real measure of the actual degree of social change implied in and asked of us by this modern history – that site art is grounded. Whether site art may or may not be made up of things, objects or pure phenomena, be made or found, cross boundaries of architecture or nature, be utilitarian or useless – all of that is secondary. As radical as these differences may be, they are, in fact, simply the surface manifestations of an even more profound set of questions – questions that rise from a change in our art ethics. As the post-modernist generation, we are being asked to consider an extended reality, to no longer hold, or hold in the same way, those abstract distinctions and limitations implicit in pictorial perception (reality). Instead, we are being asked to consider a perceptual reality that is more deeply circum-stantial. We are being asked to consider an aesthetic that is not held to be the equal of making, but includes the phenomenal as well. And we are being asked to make sense of a world in which individual quality judgment is an integral part of our social deci-sion-making processes.

My first response to the Seattle site was that it did not need steel or granite, and that it *did* need to be lightened (cheered) up and, if possible, to be transformed into a "green" oasis in its very grey surrounding. My first proposal "Three-Ring Maze" – raised rings of grass – had a strong graphic read from above, good interaction (it was fun to pass through), and would likely have been a pleasant place to spend a moment. What it lacked was visual indentification from the street. Later, when we looked into the question of weight loading the plaza, it was discovered that the initial construction of the plaza had been modified by cost restrictions in such a way as to allow loading only at the points where columns existed in the police garage below, so this proposal proved unfeasible.

This limitation, however, eventually keyed the initial formal quality of my final proposal "9 Spaces, 9 Trees." The architecture of the nine spaces is drawn (to the height of 16') in blue fencing material. A planter which is also a four-sided bench is set in the center of each square (at the point of the support columns). Inside each planter is a red-violet leafed, flowering plum tree. Each tree, and the plaza as a whole, has a border of seasonal red, yellow, green ground cover.

The plaza now has a strong graphic read-down from the surrounding building (from the city jail as well as the mayor's office), an arresting kinetic interplay between the layers of blue screening and the red-violet leaves of the trees in passing, and it affords a gentle interaction when one is passing through the plaza. In time, "9 Spaces, 9 Trees" has become a nice place to sit, rest, and brown bag.

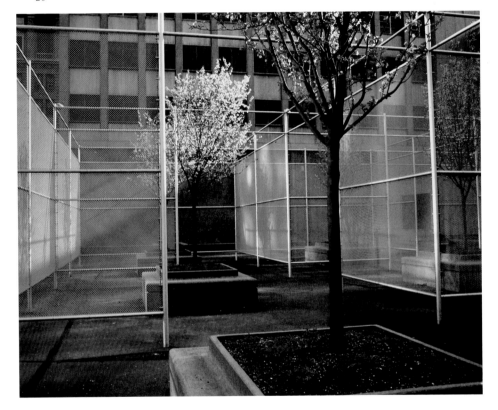

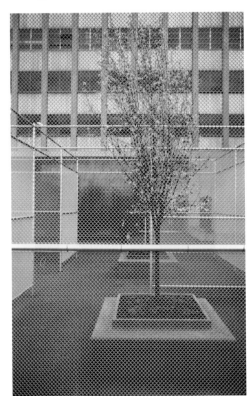

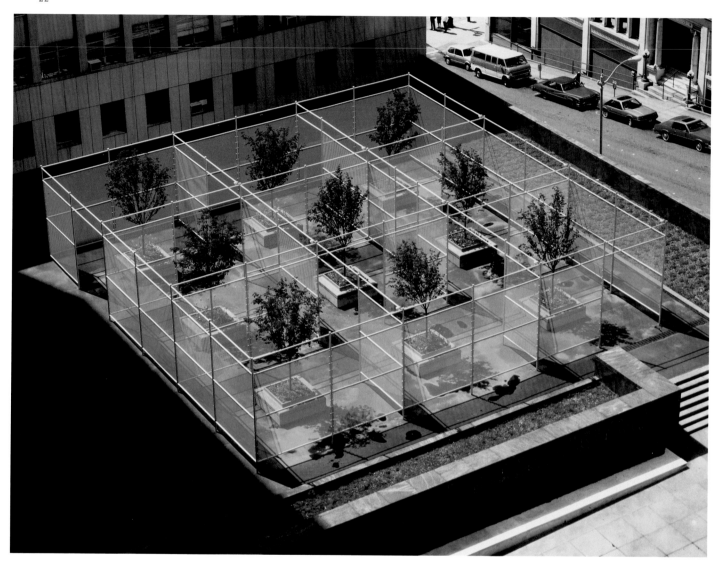

20 *Installation (section):* Spring
21 *Detail:* Screen
22 *Detail:* Flowering

San Diego:
University of California

Project Site: University Campus

Sponsor:
Stuart Foundation Sculpture Collection:
Jim DeSilva
Director: Mary Beebe

Project Initiated: October 1981

First Site Visit: November 1981
I began with the whole campus as a potential site, but very easily zeroed in on the stands of eucalyptus groves as a truly unique amenity that distinguished this campus from any other I've seen. Students move freely through the groves day and night. This is a rare opportunity for a natural confrontation in a beautiful nature place. Lovely changes of light and mood made it possible to do something very gentle here.

Project Proposal: February 1982 – "Two Running Violet V Forms"

Engineering: Keith Martin

Project Completed: 1983
Construction: Jack Brogan
Planting: Paul Mahalik, Mathew Gregoire, Frank Cole

Materials: 30' high 5" dia. ¼" wall stainless steel poles
Cross members: 1¼" dia. ¼" wall stainless steel
Fencing: Kolorgaard ⅝" aperture plastic coated (special-order blue-vilolet)
Fittings, turnbuckles: stainless steel Marine Hardware

Project Photography:
Project: Joan Tewkesbury, Mathew Gregoire
Panorama: Jack Rankin

This project was a joy for me to do, both in terms of the people involved and the opportunity presented by the site. The U.C.S.D. campus is laced with stands of eucalyptus trees that give this campus a particular grace. Students, faculty, and visitors alike use these groves; passing through in a random way, to and from everywhere on the campus. This provided that seldom encountered opportunity for a natural confrontation.

Most often, our "confrontations" are only with the conceptually isolated art event restricted to the structured format of the art place* or bound up with the precedents of park, plaza, and pedestal. On occasion there are those "art events" when we are asked to make pilgrimages to some out-of-the-way places—trips too often cluttered up with mystiques and pretensions—art trips that overlook how we arrive, or where we are coming from, as a real part of what we can know. For example, one of the problems with "white room art" is the idea of having to take off your shoes. The ritual of that act changes (clutters) the experience of the room.

The natural confrontation is that rare occasion with the unsuspecting potential for letting us "see again." Not art per se, or ritual, but perceptual interaction with "phenomena" unattended or overly habituated—an art that calls us to attend to the pure potential in our circumstances as a whole piece. Here the references of our knowing are not art history or the prior ouevre of the artist, but rather the actual qualities of the situation and our "being" in it.

Here, in these stands of eucalyptus trees, was a world rich in subtleties, changes in mood, and real events—I found out later, the particular site I chose is the habitat each year for thousands of migrating Monarch butterflies who fill the groves with their yellow/black fluttering. My response, "Two Violet V Forms," contributes a feeling, high up in the trees, 15' to 30' off the ground, a feeling accomplished through the suspension of a sometimes bright, sometimes transient, thin veil of violet color carried on stainless steel poles, which in turn blend in size and color with the forest of

*Now accompanied by the latest and most barbarian aid to seeing, the electronic lecture, plugged in your ear.

straight, smooth tree trunks. Along the base, like the leaves from the trees, the color is echoed on the ground in the form of violet-blossoming ground planting. Over time, as the newness has worn off, the piece has fused gently into the whole.

Berkeley:
University of California

Exhibition: Space as Support

Sponsor:
University Art Museum
Director: James Elliott
Exhibition Curator: Mark Rosenthal

Project Initiated: November 1977
"Space as Support" – an exhibition in four parts:
Daniel Buren, Robert Irwin, Carl Andre, Maria
Nordman

First Site Visit: February 1978
Overwhelming concrete bunker-like construction.
Very aggressive space despite, or perhaps because
of, the architecture's commitment to a mysterious
geometry. On the whole, the plan of the museum
seems illogical. It would be interesting if I could
find and reveal the plan's lynch pin.

Project Proposal: May 1978 – "Three-Plane
Triangulation"
Engineering: John Barnes
Special fluorescent fixtures designed in collabora-
tion with Doug Herst
Fixtures donated by Peerless Electric

Project Completed: March 1979

Materials: 1768 lineal feet of extruded aluminum
fluorescent fixtures, #221 8' daylight fluorescent
tubes, 1/8" stainless steel cable

Project Photography:
Site: Dale Wilson Smith
Project: Mark Rosenthal

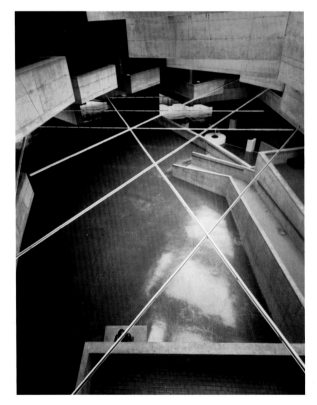

This project (exhibition) was conceived in response to the over-whelming effect the museum's architecture was having on the museum's "ordinary" exhibitions program. The conceit of the Berkeley museum architecture is by no means an isolated case. During the past 30 years we have all stood witness to the explosion of "culture" in the form of a museum building boom, architect and benefactor running amock together to form "the Edifice Complex" in Culture building. These museums often look best when not all cluttered up by other people's art.

The architecture in this case has an eccentric "fan and stack" character. The plan "fans" out from two slightly askew apexes, and everything else is a play off of the resulting proliferation of triangle forms. My response "Three-Level Triangulation" was to take the architecture at face value and simply overlay a second organizational scheme, in the form of a line-plane drawing – three stacked planes made up of lines of light, climaxing in an equilateral triangle (the lynch pin) at the center (apex) of the museum space.

Each plane's level is established by beginning with the lines of light fixtures attached directly to the ceiling of each of the three prime levels of the museum building. From there, the "lines of light" run out into the open space and to the far ends of the building. Note: this includes passing directly through the glass walls in places to complete the planes in line with the building's edge. The "lines" read as lines and not light sources because of the skylights in the center and the glass walls, which provide a daylight ambience to much of the space.

To accomplish this project, it was necessary to design and construct special fluorescent fixtures of extruded aluminum (in bar-shaped, 20' sections) capable of spanning, in straight lines, distances of up to 100' in length—fixtures that could be suspended from $1/8$" stainless steel cable with a clean attachment so as to virtually disappear in the open space. This was a very complex installation (the placement of the fixtures needed to be determined with a laser transit) and could not have been accomplished without the expertise of John Barnes, Doug Herst, and Mark Rosenthal.

25 *Site:* Museum Interior
26 *Installation:* Down View

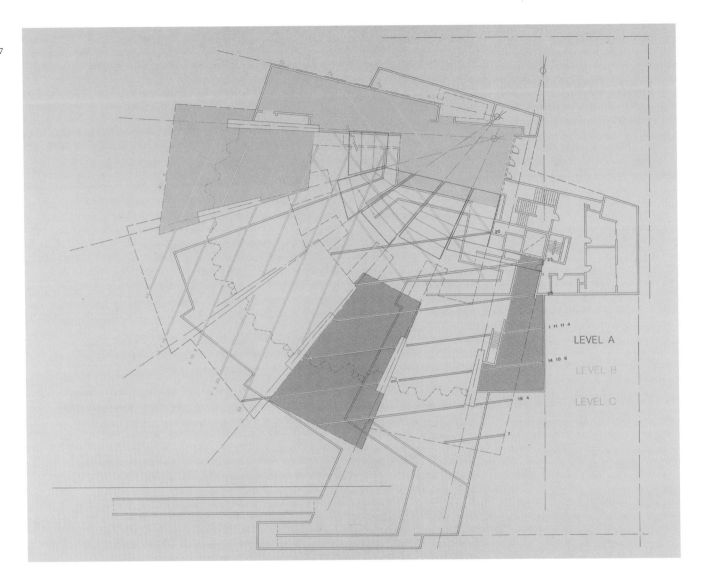

LEVEL A

LEVEL B

LEVEL C

27　*Drawing:* Plan View
　　"Three Level Triangulation"
28　*Installation:* Up View

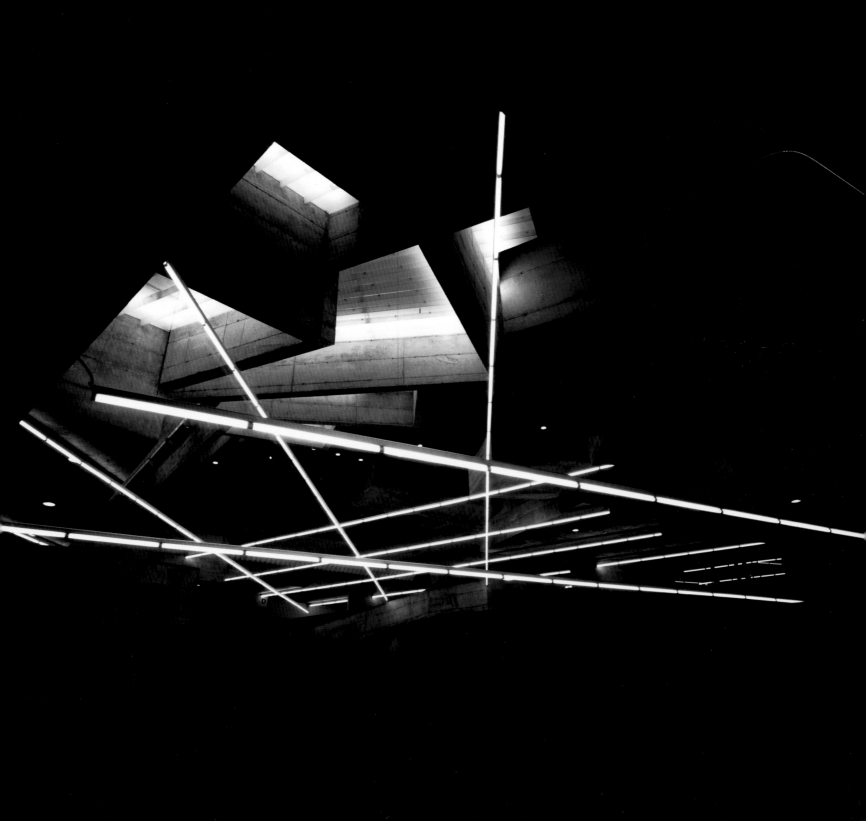

Venice, California

Project Site: 78 Market Street

Sponsor: Malinda Wyatt

Project Initiated: February 1980

First Site Visit:
I had known this space and wanted this opportunity since 1968. At that time the space next door, 72 Market, was my last studio (virtually a carbon copy of 78 Market). I had originally intended to do something similar at that time, but was forced to give up the place by the Building Department who were miffed at changes I had made in preparation for "housing" NASA's 1st International Symposium on Long-Term Space Travel.

Project Proposal: March 1980 – "One Wall Removed"

Project Completed: May 1980 (5 days)

Materials: Voile tergal (scrim) 420 cm. light construction and framing materials

Project Photography: Project documented for one full day, every minute.
Peter Lake

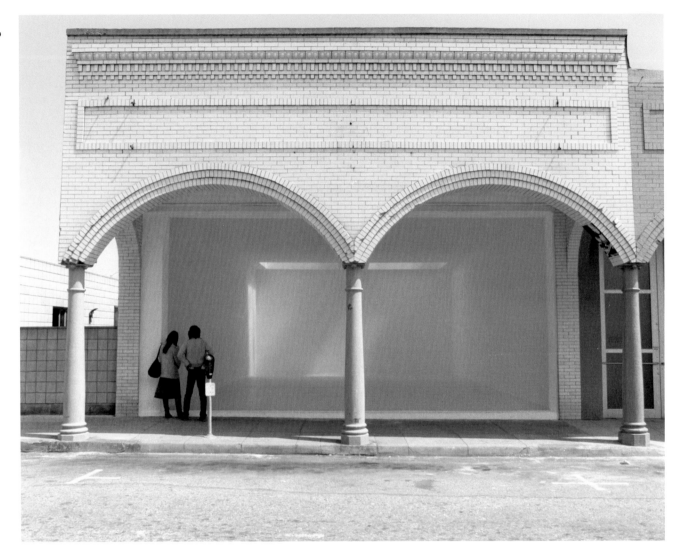

This project was the result of an odd coincidence. As the artists' representative on the fledgling board of the not-yet founded Museum of Contemporary Art, in a dialogue on the course of the museum, I was arguing that a contemporary arts museum needed to begin by identifying itself with the quality of its program, and that we should therefore focus our limited funds on providing an "Active Forum for Art and Artist." It was an argument I was losing to the more practical-minded who, on the whole, were stuck on the more "concrete values" of collecting.

Among many things, I tried pointing out that in the natural order of things, an active program would in time lead us to an understanding of the role this museum would need to play in collecting. Furthermore, I argued, the fact is, the role of the "museum" is in transition and any answers regarding its eventual form would emerge from that program (dialogue). I was advocating a kind of learning in the field, a process of sorting out the various types of meaning implied in the current range of activities.

My gut questions were, Given how much of that activity is simply uncollectable, doesn't it make you uneasy to simply perpetuate a system which cannot even deal with – i.e., collect, hold, or record – anything which does not exhibit the properties of object (thing), permanence, or image/form? What do you make of a "history" – i.e., a structured system – with such a built-in bias that it has excluded anything essentially non-object, impermanent, or phenomenal? Isn't something of value lost here? Are not these the very issues, repeated over and over now – direct experience (responsibility) vs. prestructured expectation, phenomena vs. permanence, presence vs. abstraction – which we are summoning when we employ the term "modern art?" And, what kind of honor have we achieved when we choose to collect the works but continue to ignore the real consequences of their meaning? Now, if a so-called contemporary museum chooses not to respond to these questions, who will?

Finally, I decided the best way to make my point was to *give* the board members a working example, something that would qualify as art in their "eyes," belong to them (I made it a gift to the museum), and yet be lacking in any of those properties which would allow them to take hold of it as a collectable. The coinci-

29 *Installation:* "One Wall Removed"
 Morning

dence came in the availability of 78 Market St. and a long-lost opportunity. Malinda Wyatt had made plans to fully refinish her space, including providing a new front on the building. She offered me the use of the space in the interim.

My response "One Wall Removed" was to use the clean white space – 30' wide, 80' deep, 12' high, with two boxed-in skylights set $^2/_3$' of the way back into the space – by removing the front wall facing the street and stretching in its place a sheer white scrim, in effect creating as a tangible focus the shifting qualities of light and the varying visual densities of the space across the periods of the day. It was quite beautiful.

To press the issues, the building went unmarked and the work unlabeled, thus allowing the casual passerby the full excitement of discovering this uncluttered experience, free for the taking by anyone with "eyes." Perhaps it takes only one such "personal" art experience to alert you to the latent potential for beauty in pure phenomena as well as in worldly things?

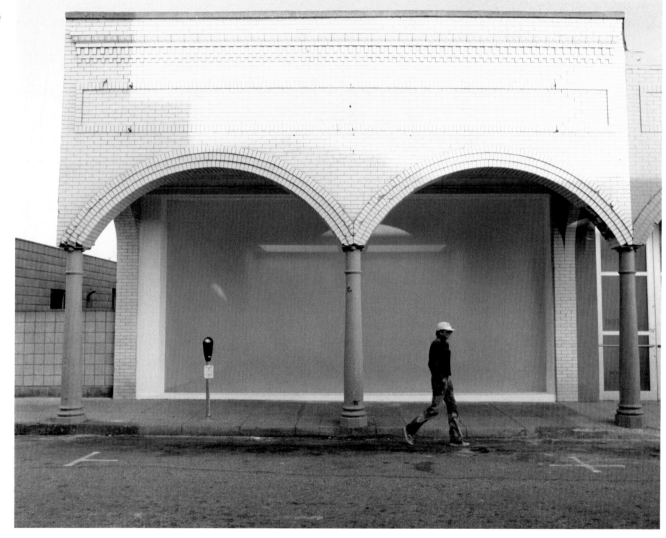

Dallas

Project Site: John W. Carpenter Park

Sponsor:
Southland Financial Corporation
President: Dan Carpenter
National Endowment for the Arts
City of Dallas, Texas

Project Initiated: March 1978

First Site Visit: April 1978
The site was a dusty, abandoned jigsaw puzzle, divided everywhere by busy streets accessing the northern approach to downtown Dallas. A large section of freeway forms the backdrop of the site and a main offramp exits through the site's center. Whatever is proposed will need to be visible and effective at thirty miles an hour, traveling in a number of directions. Given this, the budget for the project is clearly not equal to the scale of the site.

Project Proposal: September 1978 – "Portal Park Slice"
Made in collaboration with the S.W.A. Group of Landscape Architects: William Keege, Jim Reeves

Engineering: Charles Terry

Project Completed: December 1980
Construction: Ed Bell Construction Company

Project Dedicated: September 1981

Materials: Cor-Ten Steel concrete footings, earthen mounds (grass), and extensive planting

Project Photography:
Site: B&W stock shots
Project: Danny Bersotti - Tim Fox

31

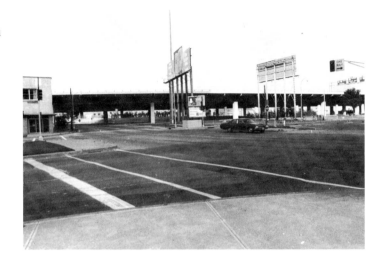

32

I was brought into the project by an N.E.A. Art in Public Places panel to try my hand at doing something with a "displaced grant" left over when the city acquired the required Sir Henry Moore sculpture for the original site – a plaza in front of City Hall.

While it is a condition of such grants that they be unfettered, I soon discovered that this "jigsaw" site was already committed in an exchange of parcels of land between the city and a developer, as part of which the developer had agreed to provide a park for the city on the city's land, which in turn was partially funded by an old city referendum for such an amenity. Further unbeknownst to the N.E.A., the developer Dan Carpenter had already commissioned a park plan. All of which made my sudden appearance on the scene a potential fly in the ointment at best.

But far from being a problem for me, the park idea made good sense for the site and created a budget that was equal to the task. I asked if I could look at the plan and visited the landscape architect's offices in Sausalito, California.

My proposal "Portal Park Slice" was a simple modification of their plan. I suggested removing a number of concrete (decorative) retaining walls – freeing up the mounds of grass to be more organic "sculptural forms" – and replacing them with a line of Cor-Ten steel (12' high, 1" thick, and 700' long) cutting like a knife through the mounds of grass, intersecting every passing street and in effect forming a dramatic gatelike (portal) passage into the city from the north.

The intention was to turn the entire jigsaw puzzle of a site – steel line, steel and concrete expressway, intersecting streets, mounds of grass, strands of tress – into one sculptural interplay of formal and organic geometries, a whole, furthermore, that could be seen and experienced in passing at thirty miles an hour.

Can we actually claim "mounds of grass" as sculpture?

You might just as well claim that everything has a sculptural potential. (Elsewhere I have already claimed everything to have a potential for beauty.)

What then do we mean by the term "sculpture?" What good is a word that includes everything? For instance, how do we now distinguish between sculpture and landscape? And sculptor and landscape architect?

Isn't the "art object" actually understood as a distinct and special category of thing?

What actually happens to what was once distinct and special when we fold it into the fabric of its circumstances? Into our daily lives? Gain and loss?

Are you intrigued by the possibilities – or put off by the complexities?

33

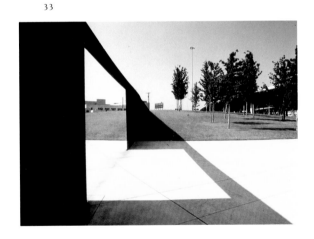

34

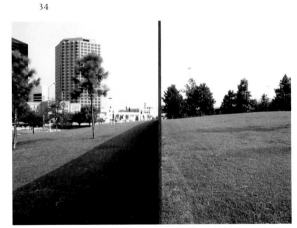

35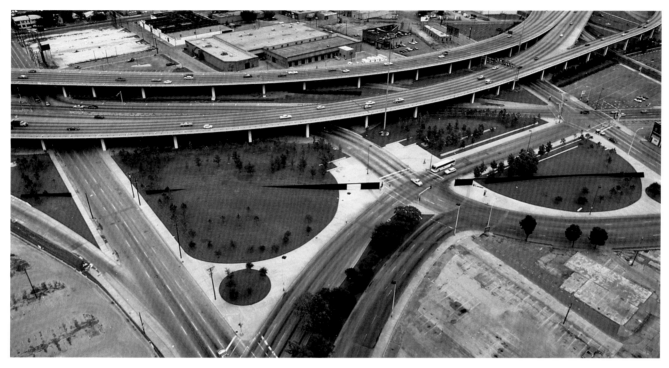

36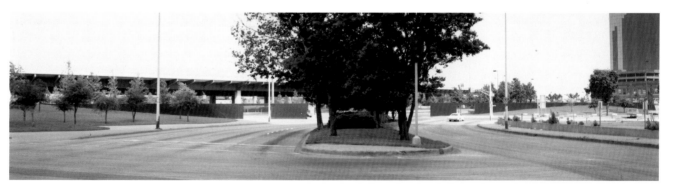

New York

Project Site: Battery Park City Commercial Plaza

Sponsor:
Battery Park City Authority, Richard Kahan
Developer: Olympia & York
Architect: Cesar Pelli

Competition:
Battery Park Fine Arts Committee
Chairman: Victor Ganz
Artists selected: Siah Armajani-Scott Burton (ASA team), Harriet Feigenbaum, Richard Fleischner, Robert Irwin, Robert Morris, Athena Tacha

Project Initiated: December 1982

First Site Visit: January 1983 (all artists)
The Hudson River has to be the main feature of this site. And while the view of the New Jersey shore may be less than thrilling, the planned river promenade has a nice potential and brings you from both directions into the plaza which becomes the focus of the entire development, the place where everything happens. This could be a major New York meeting place with a potentially heavy pedestrian traffic, but it will need to be carefully thought out so as to foster an easy flow and interesting mix of people and uses. A good balance of open and commercial spaces must be maintained. The scale of the plaza is small, and it lies in the shadow of the architecture; add to this the need for the plaza to service the users of the four towers and it seems desirable that any plaza plan respect the architectural and thematic cues already in place.

Project Presentation: April 11, 1983 – "Three Primary Forms"

Competition Winner: April 22, 1983 – The team of Siah Armajani and Scott Burton.

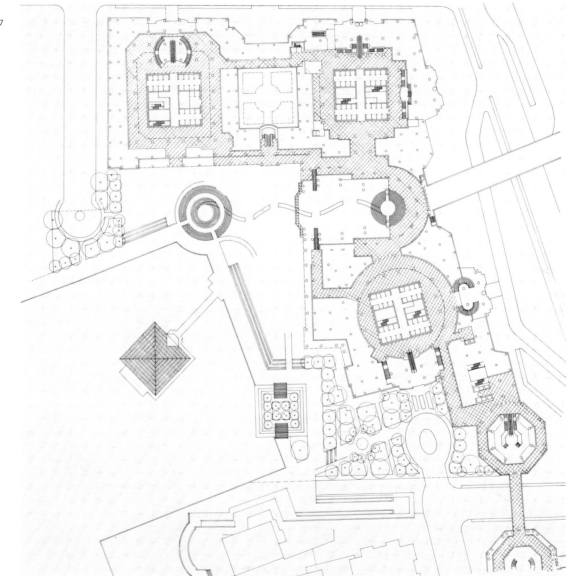

Our first site visit was made on a cold and rainy day. The site was ankle-deep in mud, and there was nothing to see of the project. Still, it was obvious that the river and the rectangular intrusion of the cove would need to be the key elements in any plaza plan. The angular geometry of the cove was reinforced by an earlier agency decision to place the entire Battery Park plan in line with the existing city grid; this in turn forced the interface between the elements of the plaza and the cut of the cove to be angled askew (see master plan). This factor, coupled with a separate agency decision not to do another "modern" development but instead to reference the whole development back to historical New York, cast in my mind the two principal forces. Odd: I used to think New York would constitute my first look at a twenty-first century cityscape. But if you polled New Yorkers, you'd find they would vote back in the gas lights and cobblestone street. They're very nostalgic about the place.

Cesar Pelli reinforced the "geometry" into a "given" by setting Tower B in his plan at an angled counterpoint to that of Towers C and D. Then he responded to the "old New York" requirement by giving the top of each of his towers a unique theme element, à la Chrysler Building – pyramid, step-pyramid, and dome. However, there were some problems in this initial plan that needed considering: (A) The plaza was undersized in relation to the architecture; (B) The plaza space felt out of balance (the lack of a fourth quadrant created a seeming void on the water side); (C) The plaza was too small for the projected volume of people-use.

The key decision in putting together my proposal "Three Primary Forms" was to bring the three top elements – pyramid, step-pyramid, dome – down into the plaza as sculptural forms and to give them sufficient scale to act: by establishing (A) a plaza of human scale; and yet (B) of a scale large enough so that one element could be developed to fill that void left in the "lost" fourth quadrant of Pelli's plan; with all of this accomplished in such a manner that (C) each "sculptural form" would double as a functional form.

(1) Dome. I inverted the dome into a stepped circular amphitheatre, in which a flexible stage-bandstand could be placed on the water side and play back to those seated in the cafes as well as in the amphitheatre, or else located in the center for a theatre-

37 *Drawing:* Plan View,
 "Three Primary Forms"

in-the-round. At other times, the dome, with a narrow line of
water swirling into its center, would act as a sheltered place for
sitting (a wind condition prevails in this corner) and taking in the
sun. Note how the placement of the dome also directs the flow of
pedestrian traffic through the most critical corner of the plaza. The
steps, ring paths, and curved ramps each articulate the foot traffic
in a variety of ways.

(2) Stepped-pyramid. A red granite-sided sculptural form, with
two sets of walk-up steps and an out-of-the-way arbor garden at
the top. A place to sit with a view of the water, the plaza, and the
promenade. Note its placement so as to bring the walking path
"inside" between the walls of the pyramid and the formal garden
to the south, thereby creating a change of pace and a sense of
entrance to the plaza. A similar sense of narrowing to create a
plaza entrance occurs at the north end as well.

(3) Pyramid. A glass pyramidal form placed at a crucial angle
out over the water, thereby forming the "lost" fourth quadrant of
the Pelli plan, creating a closure and a much-needed sense of place
for the plaza. I suggested several uses for this "pyramid" — a
greenhouse, an orchid garden, a small bird aviary, a dock for the
Statue of Liberty boat tour, or a restaurant. It had become clear in
discussion that the principal amenity of the Pelli plan (its winter
garden) had become severly limited in use by code restrictions.
The pyramid greenhouse could therefore partially complete this
theme as well.

Add to this, finally, a granite paving plan (see color drawing)
developed to take advantage of anticipated light patterns gener-
ated by the tower facades, and a well-developed planting plan
(carefully adjusted for season, color, smell, scale, texture) for the
formal garden south of Tower B, which would then provide a sig-
nificant change of pace from the populous plaza area — and you
have the proposal. It's curious to me that no other proposal even
mentioned planting — a serious opportunity that artists generally
overlook. Don't these organic instances present a sculptural oppor-
tunity? It seems odd to me not to consider the presence of trees,
flowers, grass, etc., and their textures, colors, smells, and sounds as
aesthetic potentials.

38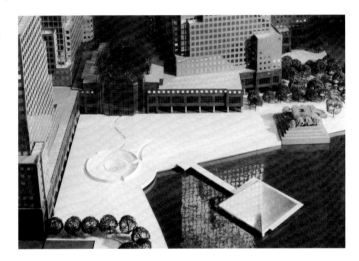

39

40

41

Washington, D.C.

Project Site: Old Post Office Atrium

Sponsor:
General Services Administration
Director: Rear Admirals Freeman and Marshall
Arts Administrators: Don Thalacker, Julie Brown,
Marilyn Farley

Project Initiated: October 20, 1979

First Site Visit: November 1979
A rich architectural space. Great natural light. Main
feature: approximately 700 or 800 windows and
window forms facing onto the atrium space. The
void is in the center. Project underfunded for the
scale of the space. Need to respect (to flow with)
the architecture.

Project Proposal: April 1980 – "56 Shadow Planes"

Engineering: Martin Associates, Los Angeles

Project Approved: April 1980

Project Completed: September 1983
Construction: Jack Brogan
Note: Proposal was modified to forty-eight planes
because of the additional clutter of the commercial
development on the first and second floors.

Project Photography:
Site: Rob. Hammel, Arthur Cotton Moorse
Associates, Washington, D.C.
Project: Don Thalacker, John Tennant

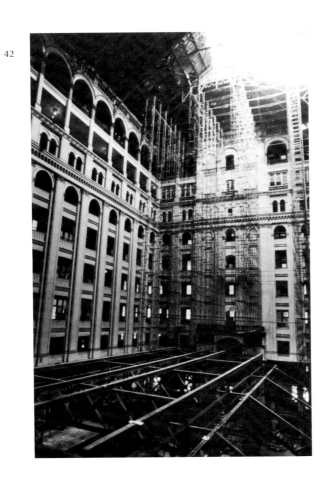

42

The "Old Post Office" is the first mixed-use project undertaken by the G.S.A. – a restoration of a classic old piece of architecture with government offices (N.E.A. - N.E.H.) on the upper floors and a commercial food fair on the first and mezzanine floors. The building is an entertaining "landmark" piece of architecture with formal boxlike proportions and a rich complexity of detail – even a kind of sense of humor.

I was asked (with some trepidation, by Rear Admirals Freeman and Marshall, who had just inherited a scandal-ridden G.S.A. and, to their own surprise, an art program) to work with the large interior atrium space of the building. From my very first visit to the site, the key issues were clear. The architecture is the *pièce de résistance*, the transient qualities of the light, the catalyst; and the open void in the center of the space, the place where it had to all be brought together.

My proposal "56 Shadow Planes" was conceived to articulate that void. The formal grid pattern of the floating planes was conceived in response to the key architectural element of the atrium (approximately 800 windows or windowlike forms facing on the open space). The use of the white translucent screening material is intended to maximize the interaction of the planes with the light, so that the forms will gently echo the windows.

The project was intended to influence how you look at the whole space. The grid of planes is not the object of focus, the objet d'art, per se. Because the planes are translucent, your eye does not hold on the grid but moves back and forth, continuously referencing the architecture and, in effect, attending the whole phenomena.

As to how to get the whole thing to simply float out in the middle of the void – a piece of cake.

43

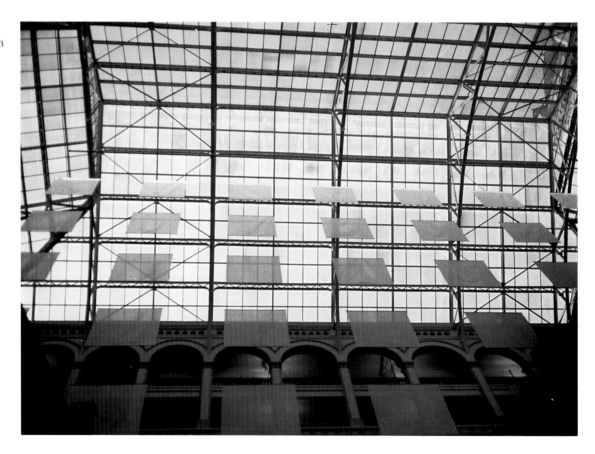

43 *Installation:* "48 Shadow Planes"
44 *Installation:* Up View

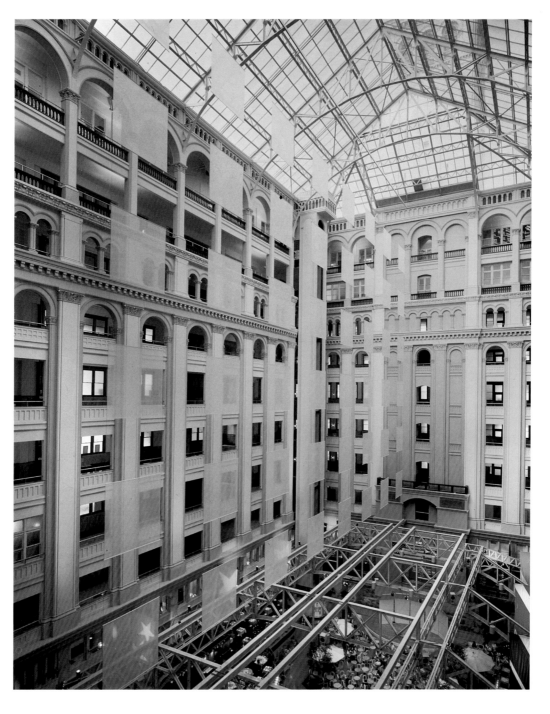

University of Minnesota

Project Site: University Campus

Sponsor:
Center for Art and the Environment (proposed),
Tom Rose

Project Initiated: December 1979
Center was proposed in a "Site" conference held
over June 15 - 16, 1979, sponsored by the Min-
nesota College of Art, Dr. Ed. Levine. I was a panel
member.

First Site Visit: February 1980
Winter is a poor time to visit this campus. Too cold
to idle about. I can't quite put my finger on it, but
this is not a "happy" place: too scattered about, no
identity, no real meeting place, poor sense of com-
munity? The Mississippi River flows through the
campus, a fact which is all but ignored. I would like
to use it, but there is no access. There are some
unplanned, unused green spaces languishing in
the architectural eddies.
Site selected: a steeply-mounded grass area caught
between the freeway accessing the campus and the
Law Building.

Project Proposal: May 1980 – "Pink Glass – Cor-Ten
Steel Sanctuary"

Materials: Cor-Ten Steel, rose colored glass (St.
Gobaine). Project abandoned – the "Center" had
not gained projected funding by 1982, after which
the glass was no longer available.

Second Site Visit: March 1982
Site selected: West plaza, bridge exit

Second Proposal: May 1982 – "Five Curved Snow
Fences" (and Bike Rack)
Project rejected by Campus Planning as having
"potential traffic problems"

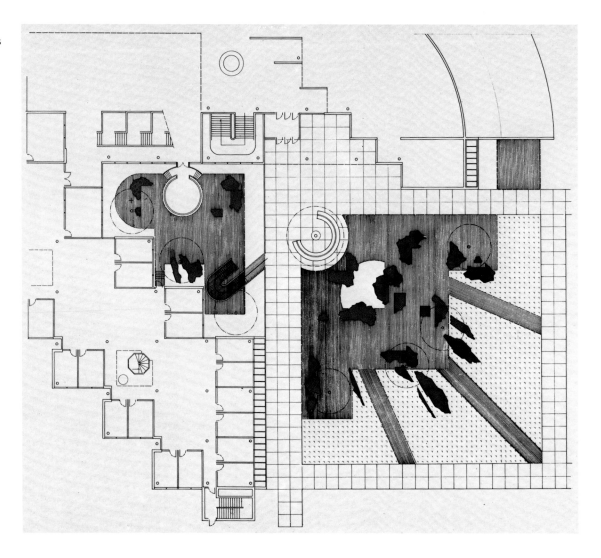

Third Site Visit: January 1983
Asked to consider a plaza for the proposed Hubert
Horatio Humphrey Center
Architect: Leonard Parker

Third Proposal: April 1983 – "H.H.H. Memorial
Plaza" . . . with a "Memorial Lectern" in collabora-
tion with Siah Armajani

Project Status: Full funding for plaza never avail-
able. Project turned over to Siah Armajani to accom-
plish the "Memorial Lectern" November 1983.
Final proposal met all of the Center's goals for a
cross-fertilization between art, architecture, and
landscape, and between aesthetic, utilitarian, and
symbolic, collaborations between artist-artist and
artist-architect.

This project began in a "Site" symposium composed of architects,
landscape architects, developers, and artists, out of which came
the idea for a cross-disciplinary center for "Art and the Environ-
ment" as a part of the University of Minnesota curriculum. Origi-
nally I was asked back to the campus to propose an "art" project
that would give the "Center" a campus identity. This process even-
tually lasted four years and involved three separate proposals;
unfortunately, neither the projects nor the Center ever came to be.

The idea of cross-disciplining artists, architects, and planners of
every ilk is, of course, not new; but neither have the reasons for
doing so diminished. The concepts and ambitions inherent in the
very idea of planning lives and living environments raise a myriad
of unasked philosophic, ethical, and common sense questions –
not the least of which is questioning the expediency (reason, ambi-
tion, ego, power, methods) of the very intention "to plan." To con-
tinue to default on these questions and simply consign ourselves
to the expediencies of the administrator-and-developer men-
talities, with their jack-of-all-trades architects and designers with

their "problem-solving" skills, is to beg the real social issues and fail to recognize what we are doing to ourselves. Instead, we press ahead along the same lines of thought, applying a band-aid now and again, but making the same fundamental mistakes. What is worse is that we are slowly paring back our own sensibilities and down-grading our expectations to the point where we accept the compounding assaults and insults of such expediences as somehow inevitable.

You would think that the current interest in "site art" would (should?) focus these issues — if not here, then where? But even in our "art world dialogues," where the very strength is that we have the time and the motive for such a philosophic approach (to begin at the beginning), such introspection is usually assailed as awkward, impractical, and, in what is (naïvely) intended as the deepest cut of all, meaningless (foolish me, I thought it was this very lack of practicality that distinguished art from such necessarily practical disciplines as, say, architecture!). Rather than sweat out the particulars, no matter how minute or seemingly obscure they may be for the moment, the rash of interest, exhibitions, writing, catalogs have on the contrary generally thrown them all — "environmental artists," "social commentary" mural makers, "social designers," "public artists," and "site artists" — into one pot and seasoned them liberally with salt-of-the-earth populism.

But back to Minnesota. This particular campus, as a place, always seemed awkward to me. Some good-bad, old-new parts and pieces all put together like a patchwork quilt, but without the quilt's comfort and flawed in its utility. Often such patchworking succeeds simply because of its inherited richness of times-meanings as opposed to the one-dimensional flatness of the standard "future plan," but here it just results in some confusion and apathy.

My charge was never broad enough that I could see it as an invitation to enjoin such questions. In response, with my first proposal, "Pink Glass - Cor-Ten Steel Sanctuary," I chose a site "lost" to the general campus, seen only at a distance or else used intimately as a place to study. The second proposal, "Snow Fence," jumped right into the middle of the most-used and confusing space (the west bank river crossing plaza) and "played" with the students passing. The third proposal, "H.H.H. Memorial Plaza,"

came in response to an invitation extended by the architect of the planned Hubert Horatio Humphrey Center and Museum. The plaza and ceremonial "Lectern" were proposed both as an entrance and amenity, as well as an extension of the museum proper. This proposal featured a plaza that was floated over water; the decking was open steel grid set on a grid of $1' \times 1' \times 1'$ concrete blocks. A grid of small $1'' \times 1'' \times 1''$ concrete blocks covers the floor of the pool and agitates the flow of water. The water flows first under the open plaza grid and then over a slanted, stepped, granite-sided fall into a lower plaza on two sides. Both plazas are set with large, natural granite rocks that serve as natural (not designed) seating for students. The planting features reed-like river/lake foliage and beautiful silvery-green Russian olive trees, acting as a gentle counterpoint to the all black, white, and grey plaza plan.

46

46 *Model*
47 *Detail*

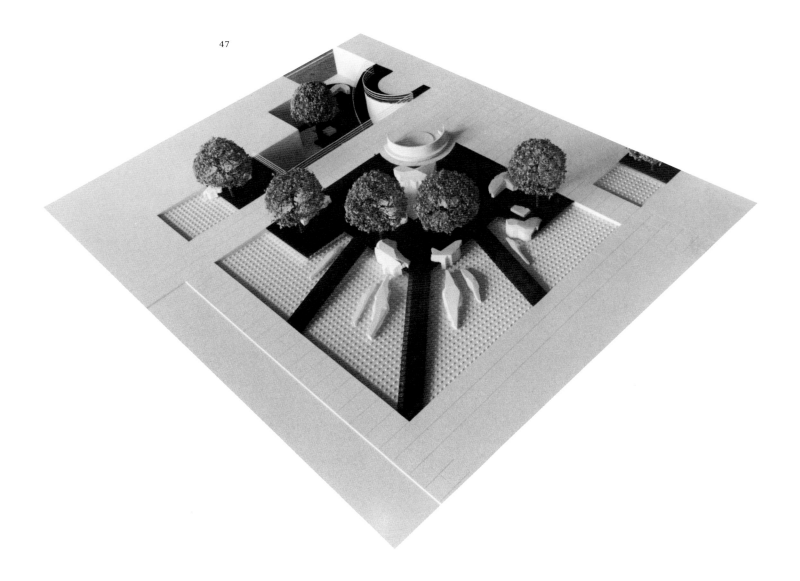

New Orleans

Project Site: Duncan Plaza (Civic Center)

Competition Sponsors:
City of New Orleans
Mayor: Ernest N. Morial
N.E.A. Design Arts
Director: Michael Pittas
Artists Selected: Lloyd Hamrol, Martin Puryear,
Robert Irwin

Project Initiated: March 1980

First Site Visit: August 4, 1980
The site is a triangular-shaped green space, with a
border of great old oak trees, that begins at the
steps of city hall and points down Basin Street. An
awkward, unbalanced area, lacking in a sense of
place. Bordered on two sides by bad 1950's motel
architecture that is out of character with the rest of
New Orleans, the site is virtually unused in a city
whose people really use their streets.

First Charette: February 2-8, 1981
Artists select landscape architect as project partner:
Lloyd Hamrol - Charles Tapley, Houston
Martin Puryear - Charles Caplinger, New Orleans
Robert Irwin - I.A. (Ace) Torre, New Orleans

Second Charette: March 9-11, 1981
Develop projects under competition conditions
Moderator: O. Jack Mitchell, Dean of Architecture —
Rice University

Proposal: "Aviary"

Presentation and Awards Banquet: March 12, 1981
Selection: "Aviary" R. Irwin — (Ace) Torre

Project Status: The Mayor never seriously consid-
ered the proposed "Aviary." He lost his nerve. It
became a political "hot potato" and a media joke.

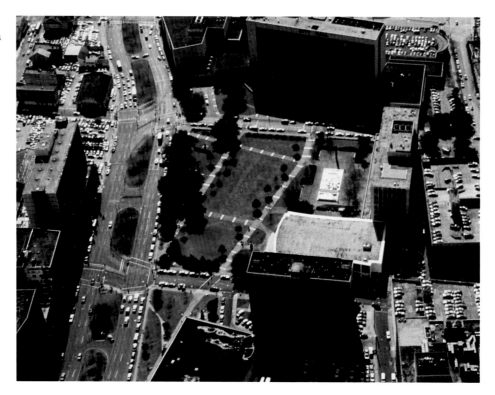

48

Project Photography:
Site: stock photography
Model: I.A. (Ace) Torre
Interiors; birds: San Diego Zoo

This project began as a competition, the initial phase of which was billed as a creative inquiry into the hows and wherefores of interdisciplinary urban problem-solving. In fact, this pseudo-inquiry contained a thinly-guised ambition to institute some old and not very creative architectural games (R/udats, charettes, etc.) into a future model for all N.E.A. Design Arts funding. If we did not accomplish anything else, the artists in this "competition process" shot down that sham of an idea.

As a charge, we were given two separate "wish lists," one generated (not substantiated) by a R/udat team (visiting firemen), who spent three days commiserating with the local denizens resulting in the "pollyanna" request that we make the site so desirable that there would be a spontaneous outpouring of people and activities. The second list, from the Mayor's office, was looking for a major tourist attraction, one capable of changing the New Orleans image and attracting a family audience.

I began by testing one of the R/udats projected user's "spontaneous sculpture exhibitions." I met with artists' groups and asked who would undertake such projects – do the dirty work. And why were they not already doing it in other places? No one had any answers for me. Planning a project based on a hoped-for phantom-user is something like the risk of throwing your own birthday party and having no one show up. As a matter of fact, the city had just finished Louis Armstrong Park a little ways down Basin Street (in a real neighborhood and with two operating theatres), and it was a no man's land.

So all this wishing needed to be looked at straight in the eye, and the sobering facts were we were facing a dead park surrounded by bad 1950's modern motel architecture with no real neighborhood (two things which the rest of New Orleans is rich in). The project had no funding in hand, no idea of programming, and no budget for maintenance (Charles Moore's notable "Piazza de Italia" lay rotting a few blocks away). How do you plan a public park with no maintenance?

My proposal "Aviary" was generated out of these considerations and my sense of what the site needed. In walking the city, I was impressed by the grass levees that surround it. I was equally impressed by the beautiful trees and rich flora (a few degrees once or twice a year from being semi-tropical). In my walks, I found the Audubon Zoo in a lovely area outside downtown. This zoo was the most successful (grown from 250,000 to 1.2 million visitors a year) and progressive (a whole new landscape plan of open environments for its inhabitants) organization in New Orleans.

I took my proposal to the zoo's director (Ron Forman) and asked if he would be interested in a "showcase" downtown. I would provide the facility. He would provide the ornithology and botanical expertise and, in turn, it would be his to program and maintain (a level of maintenance that would allow exotic and unusual planting). At this meeting we became partners in the proposal along with Ace Torre (the landscape architect who had worked wonders with the zoo).

The interior of our "Aviary" was to be a semi-tropical ecological environment providing the tiered-sheltered high, middle, ground, and water habitats of the bird life. This environment would be protected from the street by 20'-high grass berms (levees) and waterfalls to mask the street sounds. Meanwhile, the exterior was a park in keeping with New Orleans; we preserved the oak trees along Basin Street, widening the present walk into a promenade with a variety of places to sit, collect, and watch, and room for vendors and outside food service. A restaurant facility was to be cut through the grass levee, with both interior and exterior dining areas. On the opposite side of the Aviary, the walk was a corridor of golden rain trees, which change with the seasons. At one end is a sheltered square for brown-bagging office workers. At the other

end, a set of steps is cut into the levee in front of the library. The whole complex is intended to generate that critical mass necessary to turn an area into a people place. Just as critically, the Aviary was self-supporting, self-maintained, self-programmed, a tourist attraction, a teaching tool, and an ecological asset.

49

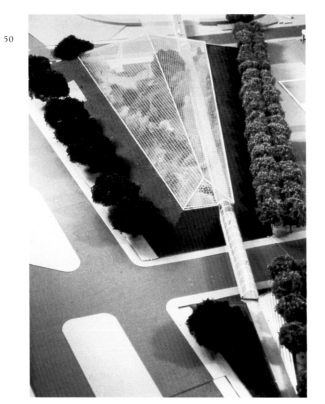

50

51

49 *Model:* "Aviary"
50 *Interior:* "Aviary"
51 *Inhabitant*
52 *Interior*

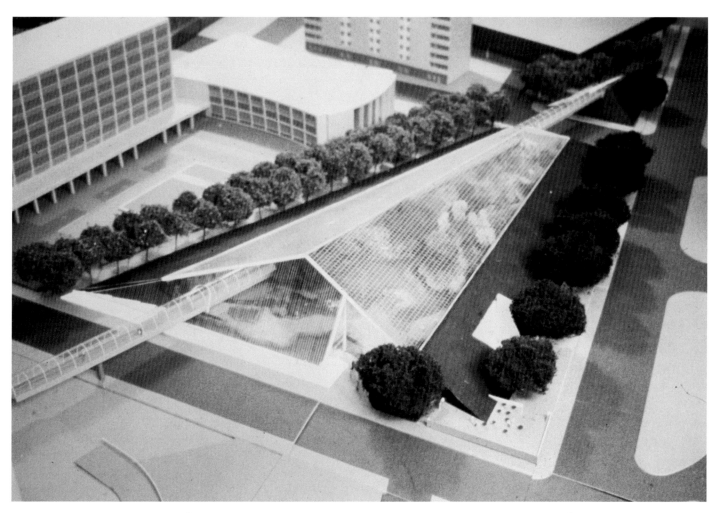

Los Angeles

Project Site: Grand Avenue Viaduct

Sponsor:
Bunker Hill Associates
Museum of Contemporary Art

Project Initiated: January 1985

First Site Visit: January 1985
The site is overpowering in scale. A two-level road-
way (viaduct) several blocks long, with two open-
ings (each approximately 11′ wide × 250′ long)
cut between the levels allowing light into the lower
street which, in time, will in any case be completely
walled in by high-rise development, for which it
will provide the main auto access. Below, the struc-
ture is a massive, dark, and brutal concrete space,
but with a strong linear graphic created by the
beamed ceiling and its relation to the two open-
ings. The upper-level street has the potential to be
a nice promenade (between the new museum and
the music center), but at the moment it lacks
human scale. The construction of the double road-
way, in its scale alone, must be viewed as already
constituting three-quarters of a major sculpture.
The challenge here is to conceive of something that
catalyzes the whole complex into something special.

Project Presentation: April 8, 1985 – "Grand
Avenue Viaduct"

Materials: Specially-designed extruded aluminum
fluorescent fixtures, stainless steel (open ended)
fluorescent fixtures

Project Status: Pending

Project Photography:
Site: Charles Christ

The site literally demands a conditional response. A more traditional sculptural approach would be swallowed up by the site's scale and visual density (not to mention the fact that there would be no appropriate place to put it). The entire viaduct structure, as I have noted, has to be seen as three-fourths of the way to already being a (good, bad?) monumental sculpture, and my creative response will have to seize the opportunity to supply the final quarter that turns the whole Grand Avenue site into a landmark sculpture. It would be best that whatever is proposed have some integral reason (purpose) and that it encompasses the entire site. This is a terrific challenge, as they say, to put up or shut up.

In approaching the site, the conditions, restrictions, and expressed desires of the developers (for some clarification of traffic flow on the two levels, particularly with regard to parking access on the lower level), make a number of things immediately apparent.
(1) The lower level will provide the sole service (truck) access as well as the only parking access and therefore cannot be blocked or restricted in any way. Add to this the fact that the side walls are obscured by a series of columns, and the ceiling becomes the only unrestricted place to work. It is in any case the most dramatic, the lines of concrete beams converging into a graphic that seems to race the entire length of the space. Fortunately, the direct interface of these ceiling beams with the two sculptural openings
(11′ × 250′) in the ceiling-roadway affords the key opportunity to tie the upper and lower street levels together with one gesture.
(2) Given this, the material for the sculpture becomes obvious. We make our sculpture the actual lighting (integral purpose) for the lower roadway.

My proposal "Grand Avenue" is therefore made up of eleven lines of fluorescent light (the fixture is an especially designed bar-shaped 2¼″ × 4″ extruded-aluminum in 20′ lengths). The eleven lines of (blue-white) light begin along each end wall (entrance) of the lower level and start out by forming an arrow shaped red light on the tip (directional signs) indicating the lower level access. The lines then pass on up to the ceiling and proceed to run along the length of the space (each line corresponding to one of the eleven structural beams). As the lines of light approach the openings, they collect together, dip down slightly, and then swing up through the openings, appearing on upper Grand as two fluid

configurations of flowing planes of light (highest point approximately 28′). The fixture changes on the upper Grand level from aluminum to stainless steel, so that an active light-reflecting finish can be worked into the fixture (making it more effective in daylight). The upper Grand fixture is also open, front and back, allowing the light to shine through. Needless to say the whole thing could be quite spectacular.

53

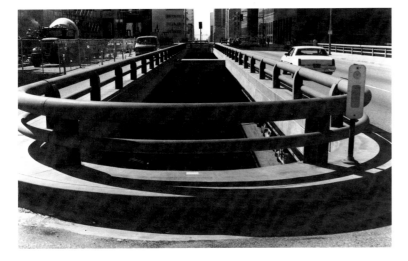

54

53 *Elevation:* Upper Level
54 *Elevation:* Lower Level
55 *Drawing:* "Grand Avenue" (overleaf)

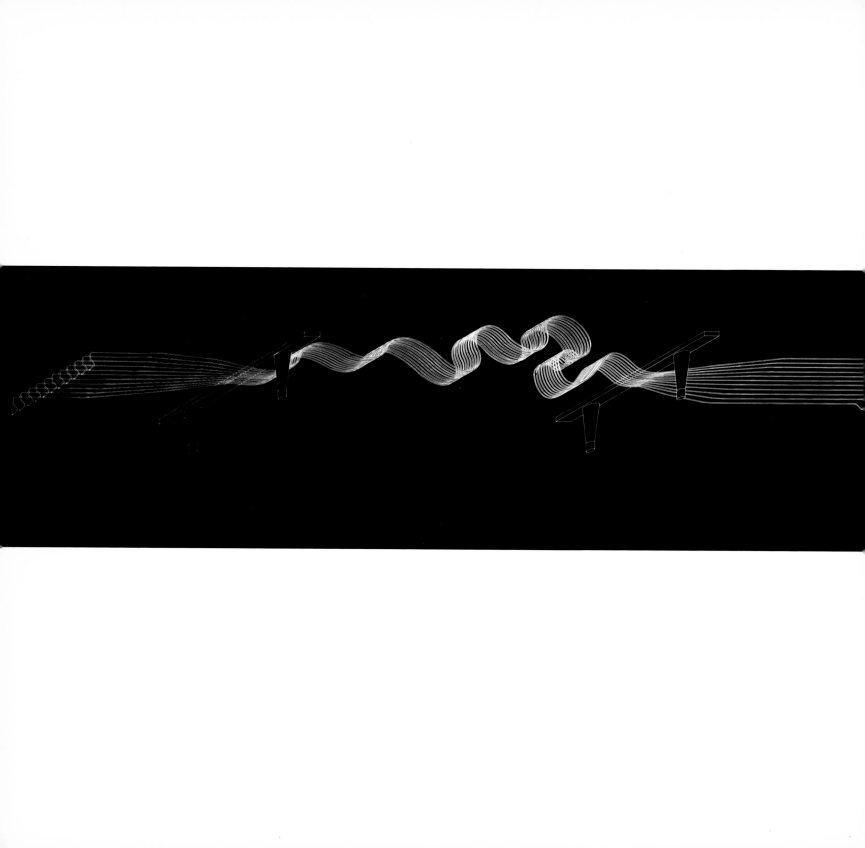

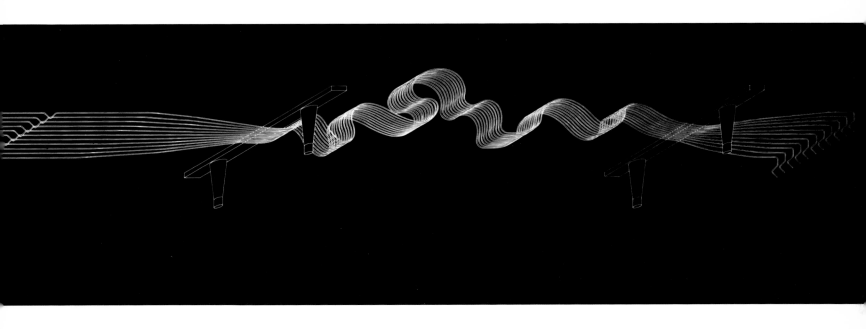

Chicago

Project Site: rapid transit arrival areas,
O'Hare Airport

Sponsor:
1% for Art, City of Chicago
Department of Arts & Architecture

Project Initiated: April 1982

First Site Visit: April 1982
A long time to spend underground in corridors.
The Murphy/Jahn plan is pretty jazzy. The area will
most likely be heavily trafficked with limited acces-
sibility. The average "passenger" is not going to
spend much time looking at art. Yet, the solution
cannot be aggressive, but must lighten the time
in transit.

Project Proposal: June 1982 – "Sound Chasing
Light"
No models or drawings of much consequence were
possible. I just talked the idea through.

Engineering and Logistics: Peterson and Vine,
Mark Rosenberg
Note: System revised and rebid, January 1984

Project Status: Project lacks adequate funding.
Proposal over original budget allotment.

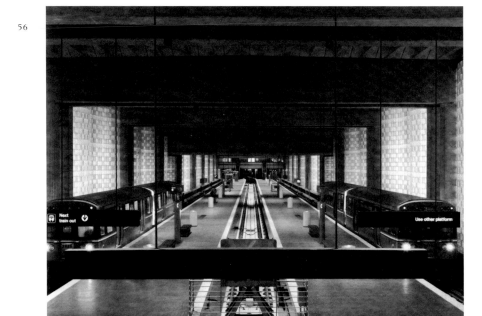

This was a humorous invitation, if you have a broad sense of humor. I was asked to visit Chicago to look at a site (obligatory 1% for art), but no one connected with the project really believed that anything much was possible or neccessary. The site: the arrival area of the new rapid transit extension out to Chicago's O'Hare Airport, which was adding some more long corridors to an airport already notorious for its long walks to the planes.

The architect (Helmut Jahn), recognizing the inherent difficulties of such spaces, had rightly left "no stone unturned," you might say; so when I asked if there were any surfaces not already "dealt with," or any spaces not already accounted for, I was told, with a wry smile, "No, now that you mention it, there aren't." After that meeting, I went back to the airport inclined to agree. It was a grey day and as I sat there waiting, I watched that familiar airport image, a line of racing lights tracing the flight path for the incoming planes. And in that moment, the idea was born.

It was fun to make this proposal, to everyone's surprise. My idea "Sound Chasing Light" was to elaborate this traveling metaphor as a periodic event intended to break up that endless sense of time (boredom) during which the traveler makes his or her way from the arriving train to the departing gate.

My plan was to space – 14' on center – a series of strobe lights (the fixture is from the wing of the Boeing 747) hung by pendants from the corridor ceilings, with a series of sound speakers – 28' on center – set in the ceiling coffers. The sound coming out of the speaker would be a combination of the G and A (emphasis on G) string picatto on a cello. All parts are electronic and digital, no maintenance.

The way I see this happening is that as you get off the train and begin your walk, a line of light would chase overhead along the platform, up the end escalator, and then disappear. The sound would then chase along behind, lingering as the "G" resonates out. All of this might be in your peripheral field the first time around, your being not quite sure what "that" was. About the time you gave up on its being "anything," it would come charging around the corner of the upper corridor, chasing and disappearing in another direction. Now your sense of anticipation would be engaged, and you might or might not see it again.

Once installed, I planned to fine tune the timing and direction of each "event" to maximize the effect (the system has total flexibility). It was my intention that this "piece" should not become too obvious, but remain more of an enigma.

57

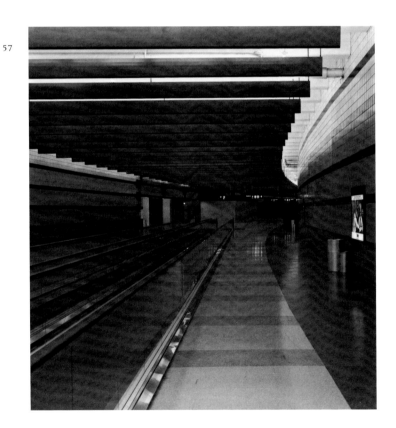

57 *Site:* Pedestrian Passage
58 *Drawing:* Plan View
 "Sound Chasing Light"

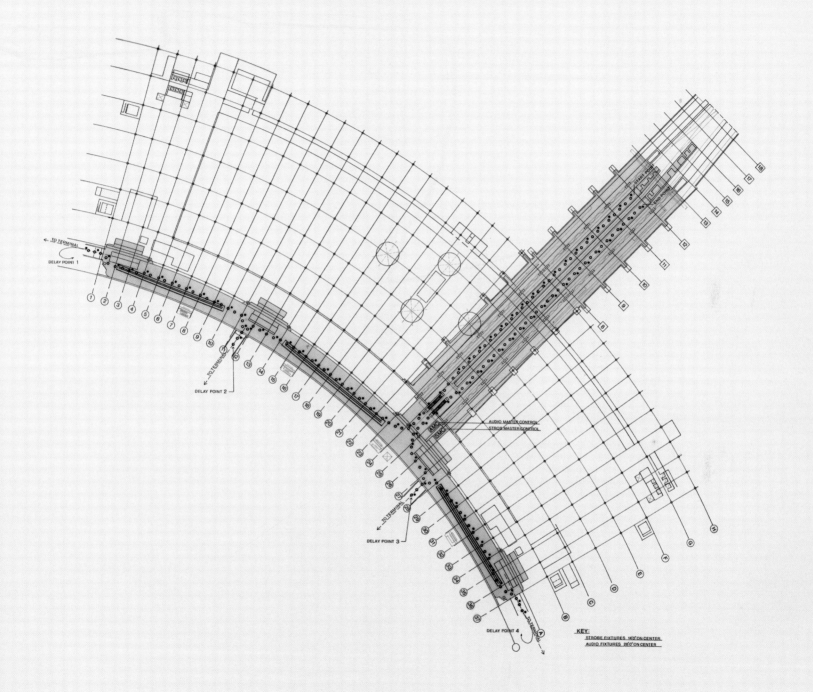

TO TERMINAL
DELAY POINT 1

TO TERMINAL
DELAY POINT 2

TO TERMINAL
DELAY POINT 3

TO TERMINAL
DELAY POINT 4

START POINT
END POINT

AUDIO MASTER CONTROL
STROB MASTER CONTROL

AMC
SMC

KEY:
STROBE FIXTURES 14'0" ON CENTER
AUDIO FIXTURES 28'0" ON CENTER

San Francisco

Project Site: Museum of Modern Art

Exhibition: A Single Plane: 324 Parts

Sponsor:
San Francisco Museum of Modern Art
Director/Curator: Henry Hopkins

Project Initiated: May 1984

First Site Visit: June 1984
The site offered consists of the whole core of the
museum's exhibition space. This includes: the
rotunda (the effective centerpiece of the museum);
an entrance-like space that leads to the rotunda,
with two small octagonal skylit spaces on either
side; two parallel, cove-ceilinged hallways on
either side of the rotunda; and a small (low
ceilinged) hall-like space behind the rotunda.
Unofficially, I have been looking at this space for
a long time now. The rotunda is a marvelously
proportioned, beautifully detailed, almost magical
beaux-arts space. The opportunity here is to turn
that last corner and make its magic manifest; the
challenge in doing so is not to "gild the lily." The
surrounding spaces will necessarily serve as spear-
carriers, in spite of the unqiue qualities of each.

Project Presentation: September 1984

Project Completed: September 1985

Materials: #360 $2' \times 2' \times 4'$ blocks,
#16 $1' \times 1' \times 10'6\frac{1}{4}''$ wall steel box tube,
#2 lengths voile tergal (12' width),
Black contact paper,
$500\frac{1}{8}'$ 32-strand stainless steel cable

Project Photography:
Site: Ben Blackwell

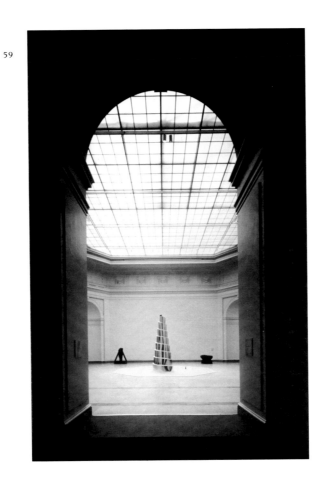

The light in the rotunda seems to literally hover in the center about 15' above the floor and may be the sole occupant necessary to the completion of the space. While this may sound fortuitous for me – light being the perfect means to "art magic" – this is not because light is thought of as "special." On the contrary, light is so thoroughly a practical necessity that it is thought of as "common" – if it is thought of at all – so much so, in fact, that we ordinarily overlook its presence all together; and light, like time and space, becomes a part of that mysterious category of "the infinitely given."

Of course, the "mystery" lies only in our cognitive omissions (repression of the phenomenally given), and the seeming "magic" lies in that moment of the phenomena's seemingly sudden reappearance. Hence, all this "mystery and magic" is the illusion. The fact is that light and its constant companion, shadow, are everywhere present and participate in a continuous and intimate *dialogue* with our perception, presenting us with an endless series of living events – events of such infinite and extra-ordinary variety, subtlety, clarity, and beauty as to astound even the most jaded reductionist, were he only to know how to participate.

Here, "in-dwelling" in the realm of our perception, light and its companion, shadow, have greater powers than mere signs, things, and matter; and greater consequence (for how we come to know the world) than mere ideas, systems, or structures.

My proposal for the rotunda arises on the one hand in response to the formal proportions of the space – a single simple gesture of a pure white boxlike form 35' × 36' × 4', set in the center of the space – and on the other hand, in response to the beaux-arts sense of detail and craft. The box form is made up of 324 2' × 2' × 4' white blocks set in an evolving grid and patterned after the design of the skylight-plane directly overhead. In this top-lit space, the white up-plane of the box form will seemingly act as a second light source and, in effect, bounce the light back up into the center of the space (the top plane will refract approximately sixty percent more light than any other surface in the space).

In the "lead-in" space, the ceiling will be painted the same color grey as the floor, and an open grid of 16 1' × 1' × 10'6" greased blue-black steel columns will be placed at approximately 48" on center intervals: a heavy, dark contrast to the light-ephemeral quality of the rotunda.

The "first" hallway will be divided by a single plane of translucent scrim material, floor to ceiling, at the center of the space, while the "second" hallway will be divided by two planes of scrim. The "third" hall-like space, in the rear, will be divided by a white translucent (completed) box of light. (These "blockings" of the peripheral spaces are intended to cause you to reenter and exit the rotunda space from different vantages.)

There will be many other changes and additions, some planned and some to be decided upon in context at the time of the installation, all with the intention of reinforcing the single phenomenon of the rotunda experience.

60

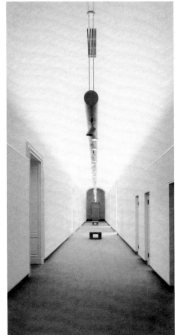

61

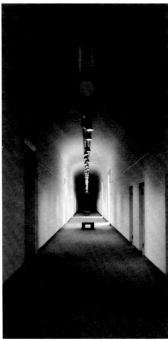

62

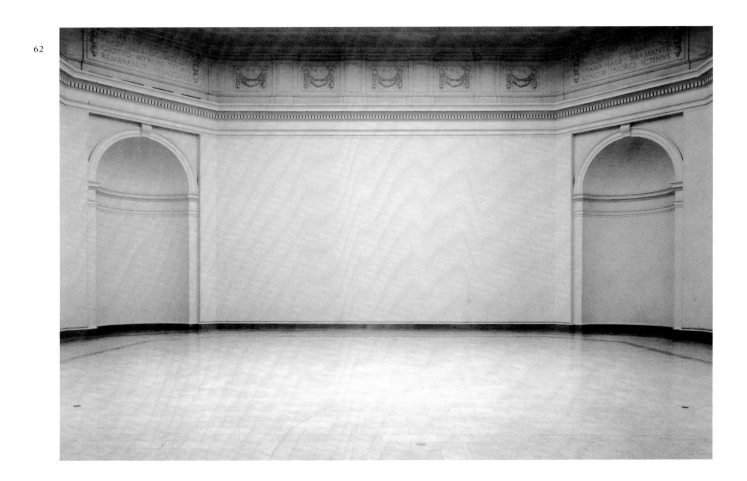

60 *Site:* (North Hallway)
61 *Site:* (South Hallway)
62 *Site:* Rotunda

Epilogue

The wonder of it all is that what looked for all the world like a diminishing horizon – the art-object's becoming so ephemeral as to threaten to disappear altogether – has, like some marvelous philosophical riddle, turned itself inside out to reveal its opposite. What appeared to be a question of object/non-object has turned out to be a question of seeing and not seeing, of how it is we actually perceive or fail to perceive "things" in their real contexts. Now we are presented and challenged with the infinite, everyday richness of "phenomenal" perception (and the potential for a corresponding "phenomenal art," with none of the customary abstract limitations as to form, place, materials, and so forth) – one which seeks to discover and value the potential for experiencing beauty in everything.

Selected Biography and Bibliography

Robert Irwin

Born: Long Beach, California, 12 September 1928

Education:
Dorsey High School, Los Angeles, 1943–46
Otis Art Institute, 1948–50
Jepson Art Institute, 1951
Chouinard Art Institute, 1952–54
Honorary Doctorate in Art, San Francisco Art Institute, 1979

Teaching:
Chouinard Art Institute, 1957–58
University of California, Los Angeles, 1962
University of California, Irvine, 1968–69
 Organized the graduate program
University of Minnesota, Fall 1981
 John J. Hill Professorship (lecture series)

Public Service:
The Museum of Contemporary Art, Los Angeles
 Founding Member of the Board of Trustees
National Endowment for the Arts
 Advisory Policy Panel, 1981–82

Lectures/Seminars:
Beginning in 1970, Irwin's teaching took the peripatetic form of accepting invitations to lecture or participate in symposia and seminars with students and professionals. He visited over 150 universities and art institutes in forty states and four departments: Art, Architecture, Philosophy, Perceptual Psychology.
Selected List:
University of California (all seven branches), Stanford University, San Francisco College of Art, University of Washington, University of Idaho, Colorado University, University of Arizona, New Mexico University, University of Texas, Texas A&M, Texas Christian, Oklahoma University, Tulane University, University of Kansas, Kansas City Art Institute, University of Iowa, Minneapolis College of Art, University of Minnesota, Ohio State University, University of Wisconsin, University of Illinois, University of Chicago, Chicago Art Institute, Detroit Institute of Art, Philadelphia College of Art, University of Delaware, University of Maryland, New York University, State University of New York, Yale University, Harvard University, Rhode Island School of Design, Wellesley College, University of North Carolina, University of South Carolina, University of Kentucky, University of Florida, University of Hawaii

1952, 1953, 1956, 1957, 1958, 1959, 1960 *Annual Exhibition–Artists of Los Angeles and Vicinity.* Los Angeles County Museum of Art.

1957 *Robert Irwin.* Felix Landau Gallery, Los Angeles.
Annual Exhibition–Sculpture, Painting, Watercolors. Whitney Museum of American Art, New York. November 20–January 12.

1959 *Recent Paintings by Robert Irwin.* Ferus Gallery, Los Angeles. March 23–April 18. Catalogue: *Recent Paintings by Robert Irwin.*
Langsner, Jules. "Exhibition at Ferus Gallery." *Art News* 58(Summer 1959):60.
Altoon/Bengston/DeFeo/Gechtoff/Irwin/Kauffman/Kienholz/Mason/ Moses/Lobdell/Smith/Richer. Ferus Gallery, Los Angeles. July 20–August 15.

1960 *Robert Irwin.* Ferus Gallery, Los Angeles. April 18–May 14.
Fifty Paintings by Thirty-Seven Artists of the Los Angeles Area. University of California Art Galleries, Los Angeles. March 20–April 10. Catalogue: *Fifty Paintings by Thirty-Seven Painters of the Los Angeles Area.* Preface by Frederick S. Wight. Introduction by Henry T. Hopkins.
Group Exhibition. Ferus Gallery, Los Angeles. June 20–July 16.
Robert Irwin. Pasadena Art Museum, California. July 12–August 31.

1961 *Group Exhibition.* Ferus Gallery, Los Angeles. April 3–29.

1962 *Recent Works by Robert Irwin.* Ferus Gallery, Los Angeles. May 8–26.
Pacific Profile of Young West Coast Painters. Pasadena Art Museum, California. June 11–July 19. Catalogue: *Pacific Profile of Young West Coast Painters.* Essay by Constance Perkins.
Fifty California Artists. Whitney Museum of American Art, New York. October 23–December 2. Catalogue: *Fifty California Artists.* Also shown at Walker Art Center, Minneapolis; Albright-Knox Art Gallery, Buffalo; and Des Moines Art Center, 1963.
Bogat, Regina. "Fifty California Artists." *Artforum* 1(January 1963): 23–26.

1963 *Altoon/Bell/Bengston/DeFeo/Irwin/Kauffman/Lobdell/Mason/ Moses/Price/Ruben/Ruscha.* Ferus Gallery, Los Angeles. June–July.
Marck, Jan van der. "The Californians." *Art International* 7 (May 1963): 28–31.

1964 *New Paintings by Robert Irwin.* Ferus Gallery, Los Angeles. April 7–May 30.
Seven New Artists. Sidney Janis Gallery, New York. May 5–29. Catalogue: *Seven New Artists.*
Ashton, Dore. "Seven New Artists." *Arts and Architecture* 81 (June 1964):9.
Fried, Michael. "Seven New Artists." *Art International* (Lugano) 8(Summer 1964):82.
Tillim, Sidney. "Seven New Artists at Janis." *Arts Magazine* 38(Summer 1964):82.
Some New Art From Los Angeles. San Francisco Art Institute. May 5–24.

Coplans, John. "Circle of Styles on the West Coast." *Art in America* 52(June 1964):24–41.

Coplans, John, Philip Leider, and Henry T. Hopkins. "A Portfolio of Contemporary Los Angeles Art: Formal Art, The Cool School, Abstract Expressionism." *Artforum* 2(Summer 1964):42–46.

1965 *The Responsive Eye*. The Museum of Modern Art, New York. February 23–April 25. Catalogue: *The Responsive Eye*. Essay by William C. Seitz. Also shown at City Art Museum of St. Louis; Seattle Art Museum; Pasadena Art Museum; and Baltimore Museum of Art.

VIII Sao Paulo Bienal. São Paulo, Brazil. September 4–November 28.

Catalogue: *VIII São Paulo Bienal, United States of America, 1966*. Exhibition organized and catalogue prepared by the Pasadena Art Museum. Essay by Walter Hopps. Also shown at the National Collection of Fine Arts, Smithsonian Institution, Washington, D.C., 1966.

Getlin, Frank. "VIII São Paulo Bienal [at Nat. Col. of Fine Arts]." *The Sunday Star* (Washington, D.C.) sec.D(January 30, 1966):1–3.

Hudson, Andrew. "VIII São Paulo Bienal [at Nat. Col. of Fine Arts]." *Art International* 10(Summer 1966):130–31.

Kozloff, Max. "VIII São Paulo Bienal [at Nat. Col. of Fine Arts]." *The Nation* (February 28, 1966):250–52.

Kramer, Hilton. "VIII São Paulo Bienal [at Nat. Col. of Fine Arts]." *New York Times* 115, sec.1(January 29, 1966):22.

Lewis, Carolyn. "VIII São Paulo Bienal [at Nat. Col. of Fine Arts]." *The Washington Post*, sec.B(January 28, 1966).

The Studs: Moses, Irwin, Price, Bengston. Ferus Gallery, Los Angeles. December.

Coplans, John. "Los Angeles: The Scene." *Art News* 64(March 1965): 29, 56–58.

———. "The New Abstraction on the West Coast, U.S.A." *Studio International* 169(May 1965):192–199.

Irwin, Robert. "Statement of Position on Photographic Reproductions of His Art." *Artforum* 3(June 1965):23.

1966 *Robert Irwin/Kenneth Price*. Los Angeles County Museum of Art. July 7–September 4. Catalogue: *Robert Irwin/Kenneth Price*. Essay by Philip Leider.

Leider, Philip. "Robert Irwin/Kenneth Price: The Best of the Lack-Lustre." *New York Times* 115,sec.2(August 7, 1966):14D.

Rose, Barbara. "Los Angeles: The Second City." *Art in America* 54(January/February 1966):110–115.

Robert Irwin. The Pace Gallery, New York. November 12–December 10.

Ives, Colta Feller. "In the Galleries." *Arts Magazine* 41(December 1966):72.

Kozloff, Max. "New York." *Artforum* 5(January 1967):56.

Waldman, Diane. "Exhibition at Pace Gallery." *Art News* 65(January 1967):14.

1967 Coplans, John. "Art Bloom." *Vogue* 150(November 1, 1967): 184–187.

Lippard, Lucy R. "The Silent Art." *Art in America* 55(January/February 1967):58–63.

Livingston, Jane. "Los Angeles." *Artforum* 6(December 1967):62.
Wilson, William. "The Explosion That Never Went Boom." *Saturday Reivew* 50(September 23, 1967):54–56.

1968 *Robert Irwin*. Pasadena Art Museum, California. January 16–February 18. Catalogue: *Robert Irwin*. Essay by John Coplans.
Livingston, Jane. Review. *Artforum* (March 1968).
Terbell, Melinda. "Robert Irwin Exhibition at Pasadena." *Arts* 42 (April 1968):55.
Wilson, William. "Exhibition in Pasadena." *Los Angeles Times*, sec.4(January 19, 1968):3.
Robert Irwin. The Pace Gallery, New York. March 15–April 11.
Baker, Elizabeth. "Reviews and Previews." *Art News* 67(May 1968): 15–16.
Simon, Rita. "In the Galleries." *Arts Magazine* 42(May 1968):64.
Gene Davis, Robert Irwin, Richard Smith. The Jewish Museum, New York. March 20–May 12. Catalogue: *Gene Davis, Robert Irwin, Richard Smith*. Essay on Irwin by John Coplans.
Feldman, Anita. "In the Museums." *Arts Magazine* 42(May 1968):54.
Wasserman, Emily. "Robert Irwin, Gene Davis, Richard Smith." *Artforum* 6(May 1968):47–49.
Los Angeles 6. Vancouver Art Gallery, British Columbia. March 31–May 5. Catalogue: *Los Angeles 6*.
Malcolmson, Harry. Review. *Toronto Daily Star* (April 20).
6 Artists, 6 Exhibitions. Walker Art Center, Minneapolis. May 12–June 23. Also shown at Albright-Knox Art Gallery, Buffalo.
Documenta 4. Kassel, Germany. June 27–October 6.
Untitled, 1968. San Francisco Museum of Art. November 9–December 29. Catalogue: *Untitled, 1968*. Introduction by Wesley Chamberlain.
Stiles, Knute. "Untitled '68: The San Francisco Annual Becomes an Invitational." *Artforum* 7(January 1969):50–52.
Late 50's at the Ferus. Los Angeles County Museum of Art. November 21–December 15.

"Light on Time." *Time Magazine* 91(May 10, 1968):69.
"Place in the Sun." *Time Magazine* 92(August 30, 1968):38–41.
Robbins, Corrine. "The Circle in Orbit." *Art in America* 56(November/December 1968):65.
"Two Generations in Los Angeles: West Coast Report." *Art in America* 57(January/February 1968):92–97.

1969 *Robert Irwin/Doug Wheeler*. Fort Worth Art Center, Texas. March. Catalogue: *Robert Irwin/Doug Wheeler*. Introduction by Jane Livingston. Also shown at the Stedelijk Museum, Amsterdam, 1970.
Recent Work by Robert Irwin. La Jolla Museum of Contemporary Art, California. August 28–September 28.
Robert Irwin. The Pace Gallery, New York. October 4–29.
Ashton, Dore. "New York Commentary." *Studio International* 178(December 1969):231.
Krauss, Rosalind. "New York." *Artforum* 8(December 1969):70.
Ratcliff, Carter. "New York Letter." *Art International* 13(Winter 1969):73–74.
Kompas IV: West Coast U.S.A. Stedelijk Museum, Eindhoven, Neth-

erlands. November 12–January 4, 1970. Catalogue: *Kompas IV: West Coast U.S.A.* Essay by Jan Leering.
West Coast 1945–1969. Pasadena Art Museum, California. November 24–January 18, 1970. Catalogue: *West Coast 1945–1969.* Introduction by John Coplans. Also shown at City Art Museum of St. Louis; Art Gallery of Ontario, Ottawa; and Fort Worth Art Center, 1970.
Seldis, Henry J. "Top Museum Aquisitions: Span Styles, Centuries." *Los Angeles Times* 88, Calendar sec.(January 19, 1969).

1970 *69th American Exhibition.* The Art Institute of Chicago. January 17–February 22. Catalogue: *69th American Exhibition.*
Bell/Irwin/Wheeler. Tate Gallery, London. May 5–31. Catalogue: *Bell/Irwin/Wheeler.* Essay by Michael Compton.
Compton, Michael. "UK Commmentary." *Studio International* 179(June 1970):269–270.
Russel, David. "London." *Arts Magazine* 44(Summer 1970):53.
Permutations: Light and Color. Museum of Contemporary Art, Chicago. May 17–June 28. Catalogue: *Permutations: Light and Color.*
Robert Irwin–Recent Work 1969–70. Artist's Studio, Venice, California. October 2–25. Work installed: Skylight–Column
Terbell, Melinda. "Los Angeles." *Arts Magazine* 45(November 1970):53.
Looking West 1970. Joslyn Art Museum, Omaha, Nebraska. October 18–November 29. Catalogue: *Looking West 1970.*
Robert Irwin. The Museum of Modern Art, New York. October 24–February 16, 1971. Work installed: Fractured light – Partial scrim ceiling–Eye level wire.
A Decade of California Color. The Pace Gallery, New York. November 7–December 2. Catalogue: *A Decade of California Color.*

Plagens, Peter. "Robert Irwin, The Artist's Premises." *Artforum* 9(December 1970):88–89.

1971 *Transparency, Reflection, Light, Space: Four Artists.* University of California Art Galleries, Los Angeles. January 11–February 14. Work installed: Stairwell–Reflected light. Catalogue: *Transparency, Reflection, Light, Space: Four Artists.* Interview with Irwin by Frederick S. Wight.
32nd Biennial Exhibition of Contemporary American Painting. Corcoran Gallery of Art, Washington, D.C. February 28–April 4. Work installed: Scrim ceiling–Acoustic point–Ambient light. Catalogue: *32nd Biennial Exhibition of Contemporary American Painting.*
Drath, Viola. "32nd Corcoran Biennial: Arts as Visual Event." *Art International* 15(May 1971):41.
Robert Irwin. The Pace Gallery, New York (installed at Donald Judd's studio, 101 Spring Street, New York). April 24–May 29.
Siegel, Jeanne. "Reviews and Previews." *Art News* 70(Summer 1971):14.
Arts and Technology. Los Angeles County Museum of Art. May 10–August 29. Catalogue: *Art and Technology.* Essay on Irwin by Jane Livingston.
Works For New Spaces. Walker Art Center, Minneapolis. May 18–July 25. Work installed: Slant light volume. Catalogue: *Works for New Spaces.*
11 Los Angeles Artists. Hayward Gallery, London. September 30–

November 7. Work installed: Transparent floor (withdrawn). Catalogue: *11 Los Angeles Artists*. Essay by Maurice Tuchman and Jane Livingston. Also shown at Palais des Beaux-Arts, Brussels (Plastic floor planes); and Akademie der Kunst, Berlin (Scrim planes), 1972.
New Works From The Walker Art Center. Henry Art Gallery, University of Washington, Seattle. November 12–December 9. Work installed: Skylight volume.
A Research Program (sociogram) for an Artist Selection Process (exhibitions). Sponsored by Market Street Project: Josh Young. 1971–73.
Baker, Elizabeth. "Los Angeles 1971." *Art News* 70(September 1971):30–31.

1972 *USA West Coast*. Kunstverein, Hamburg, Germany. January 15–February 27. Catalogue: *USA West Coast*. Also shown in Germany at Kunstverein, Hannover; Kolnischer Kunstverein; and Wurttembergischer Kunstverein, Stuttgart.
Robert Irwin. Fogg Art Museum, Harvard University, Cambridge, Massachusetts. April 7–16. Work installed: Skylight ambient V volume.
Robert Irwin. Mizuno Gallery, Los Angeles. November. Work installed: Skylight volume column.
Robert Irwin. Ace Gallery, Los Angeles. Work installed: Room angle light volume.
Robert Irwin. Galerie Sonnabend, Paris. Work installed: Split room slant scrim.

Butterfield, Jan. "Part I. The State of the Real: Robert Irwin Discusses the Art of an Extended Consciousness." *Arts Magazine* 46(June 1972):47–49.
———. "Part II. Reshaping the Shape of Things." *Arts Magazine* 46(September/October 1972):30–32.
Mackintosh, Alistair. "Robert Irwin: An Interview with Alistair Mackintosh." *Arts and Artists* 6(March 1972):24–27.

1973 *Works In Spaces*. San Francisco Museum of Art. February 9–April 8. Work installed: Retinal replay volume.
American Art: Third Quarter Century. Seattle Art Museum, Seattle, Washington. August 22–October 14. Catalogue: *American Art: Third Quarter Century*.
Robert Irwin. The Pace Gallery, New York. December 1–28. Work installed: Eye level wall division.
Matos, Jose. "Reviews." *Artforum* 12(February 1974):78.
Stitelman, Paul. "Robert Irwin." *Arts Magazine* 48(February 1974):65.
3 Rooms, One Inside Another, Scrim Division, Window. Installation: Collection Count Giuseppe Panza. Varese, Italy. Completed 1975.

Hunter, Sam. *American Art of the Twentieth Century*. New York: Abrams, 1973.

1974 *Robert Irwin–Installation*. Mizuno Gallery, Los Angeles. January 29–February 23. Work installed: Wall division–Portal.
Plagens, Peter. "Reviews." *Artforum* 12(April 1974):83.
Terbell, Melinda. "African Art in Motion." *Art News* 73(March 1973):76.
Art Now 74. John F. Kennedy Center for the Performing Arts, Wash-

ington, D.C. May 30–June 16. Work installed: Light–Corner. Catalogue: *Art Now 74*.

Robert Irwin–Installation. Wright State University Art Galleries, Dayton, Ohio. October 10–November 10. Work installed: Two story –Flat floating plane.

Robert Irwin–Installation. University of California Art Galleries, Santa Barbara. December 3–15. Work installed: Two room wall–Wall scrim.

Robert Irwin–Installation. The Pace Gallery, New York. December 7–January 4, 1975. Work installed: Soft wall.

Dreiss, Joseph. "Arts Reviews." *Arts Magazine* 49(February 1975):16.

Rosing, Larry. "Robert Irwin at Pace." *Art in America* 68(March 1975):87.

Some Recent American Art. Organized by the International Council of The Museum of Modern Art, New York. Catalogue: *Some Recent American Art*. Shown in Australia at the National Gallery of Victoria, Melbourne (Wall plane); Art Gallery of New South Wales, Sydney (Elongated shaft light V volume); Art Gallery of South Australia, Adelaide; West Australian Art Gallery, Perth; and in New Zealand at the City of Aukland Art Gallery (Slant – Light volume).

Butterfield, Jan. "An Uncompromising Other Way." *Arts Magazine* 48(June 1974):52–55.

Panza, Giuseppe di Biumo. "Environmental Art Museum." *Data Summer* 4, no.12(1974).

Plagens, Peter. *Sunshine Muse: Contemporary Art on the West Coast*. New York: Praeger, 1974.

1975 *Robert Irwin: Continuing Responses*. The Fort Worth Art Museum, Texas. July 27 through 1977. Works installed: Stairwell soft wall; Atrium scrim veil; String volume; String drawing; Four corner–Lobby; Window–Window; Black rectangle; 12 city designations of "incidental sculptures." Newspaper catalogue: *Fort Worth Star-Telegram*. Essays by Sid R. Bass (September 21, 1975), and Dr. Edward Wortz (December 21, 1975).

A View Through. California State University Art Galleries, Long Beach. September 22–October 19. Work has become permanent. Work installed: Passage window–Outdoors. Catalogue: *A View Through*.

Robert Irwin–Installation. Mizuno Gallery, Los Angeles. October 21 –November 15. Work installed: Scrim veil.

Marmer, Nancy. "Reviews." *Artforum* 14(February 1976):69–70.

Wortz, Melinda. "Self-scrutiny and Scrims." *Art News* 75(January 1976):65–66.

Robert Irwin. Museum of Contemporary Art, Chicago. November 8–January 4, 1976. Works installed: Scrim V; Black line volume. Catalogue: *Robert Irwin*. Essay by Ira Licht.

Morrison, C. L. "Chicago." *Artforum* 14(February 1976):67.

Review. *Art in America* (March/April 1975):87.

Davis, Douglas. "The Searcher." *Newsweek* (December 29, 1975):53.

Rose, Barbara. *American Art Since 1900*. New York: Praeger, 1975.

1976 *Robert Irwin–Installation*. Walker Art Center, Minneapolis. February 28–April 4. Works installed: Four corners room–Room; Window indication; Repeat slant light volume (1971).

The Last Time I Saw Ferus: 1957–66. Newport Harbor Art Museum, Newport Beach, California. March 7–April 17. Catalogue: *The Last Time I Saw Ferus: 1957–66.*

200 Years of American Sculpture. Whitney Museum of American Art, New York. March 16–September 26. Work installed: Exhibition view–Double window plane. Catalogue: *200 Years of American Sculpture.* Essays on sculpture since 1950 by Barbara Haskell and Marcia Tucker.

Critical Perspectives in American Art. Fine Arts Center Gallery, University of Massachusetts, Amherst. April 10–May 9. Work installed: Stairwell slant volume. Catalogue: Essays by Sam Hunter, Rosaland Kruss and Marcia Tucker.

Projects for PCA. Philadelphia College of Art. April 19–May 21. Work installed: Straighten gallery wall-Scrim plane. Catalogue: *Projects for PCA.* Essay by Janet Kardon. Symposium conducted by Marcia Tucker.

37th Venice Biennale. Venice, Italy. July 18–October 10. Works installed: United States Pavilion, String drawing–Filtered light; Italian Pavilion, Room–Sight line–Window.

Robert Irwin–Installation. University of Maryland Art Gallery, College Park. September–October 29. Works installed: Gallery–Volume rectangle; Lawn–Open rectangle; Hillside–Straight line; Quad indication–Crossing paths.

Painting and Sculpture in California: The Modern Era. San Francisco Museum of Art. September 3–November 21. Catalogue: Essay by Henry T. Hopkins. Also shown at the National Collection of Fine Arts, Washington, D.C. May 20–September 11, 1977.

Butterfield, Jan. "Robert Irwin: On the Periphery of Knowing." *Arts Magazine* 50(February 1976):72–77.

Hazlitt, Gordon. "Incredibly Beautiful Quandary." *Art News* 75(May 1976):36–38.

Levine, Edward. "Robert Irwin: World Without Frame." *Arts Magazine* (February 1976):72–77.

Smith, Roberta. "Robert Irwin: The Subject Is Sight." *Art in America* 64(March 1976):68–73.

John Simon Guggenheim Fellowship: 1976–77.

1977 *Waterfront Project: Redevelopment of San Francisco's Northeastern Waterfront.* San Francisco Art Institute. April 1–10. Proposal: "Freeway Monument." Project not realized.

Robert Irwin. Retrospective of early work–paintings and installations. Whitney Museum of American Art. April 16–May 29. Work installed: Black plane (42nd St. & 5th Ave.); Line rectangle (World Trade Center); Grid (Park Ave., 57th St.–51st St.–uncompleted); Black planes–light and shadow (Park Ave.); Line rectangle–Mercury vapor lights (Central Park); Grid, City plan–early vs. late. Catalogue: *Robert Irwin.* Essay "Notes Toward a Model" by Robert Irwin.

Kingley, April. "Wave the Magic Wand." *Soho Weekly News* (May 5, 1977):21.

Kramer, Hilton. "A Career that Rejected Studio Art." *New York Times* (May 8, 1977).

Russell, John. "Robert Irwin at the Whitney." *New York Times* (April 22, 1977).

Weschler, Lawrence. "Robert Irwin's Alchemy of Perception." *Village Voice* (May 9, 1977).

———. "Robert Irwin's Whitney Project: Retrospectives and Prospects." *LAICA Journal* (July/August 1977):14–23.
Space as Support. An exhibition in four parts: Buren, Irwin, Andre, Nordman. University of California Art Museum, Berkeley. Project initiated: November. Proposal: "Three-Plane Triangulation." Completed: March 1979.
Why Art? 1st International Center for Critical Inquiry. San Francisco Art Institute. November 28–30. Paper: "20 Questions."

Butterfield, Jan. "Made in California." *American Art Review* (July 1977):141.
Treib, Marc. "Architectural Versus Architecture: Is an Image a Reality?" *Architectural Association Quarterly* 9, pt.4(1977):3–14.
Wight, Frederick S. *Oral History: Robert Irwin Interview.* Berkeley and Los Angeles: University of California, 1977.

1978 *Portal Park Slice.* John W. Carpenter Park, Dallas. Project initiated: March. Completed: December 1980.
What Is Painting?: An Inquiry of Pictorial Processing. U.S. Army Human Engineering Lab, Philadelphia, Pennsylvania. April 17–19. Paper: "Notes on the Nature of Abstraction."
10th International Sculpture Conference. Toronto, Canada. May 31–June 4. Panel: Pictorial vs. Sculptural Space.
Matrix. University of California, Berkeley. October. Work installed: Line paintings (1963–64). Catalogue: *Matrix.* Essay by Lawrence Weschler.
Plagens, Peter. "Robert Irwin's Line Paintings." *Artforum* (Fall 1978).
Tilted Planes. Ohio State University. Project initiated: September. Selection (winner): January 1979. Project not realized.
Yertmans Cove Sculpture Project. Initiated: November 1978. Proposal: "Red River Line," December. Selection (winner): February 1979. Project not realized.
Portland Center For The Visual Arts. Portland, Oregon. November 1978. Work installed: Scrim wall.
Art Actuel. Switzerland. *Skinn-Annuel* (1978):92–127.

1979 *Robert Irwin: Untitled Installation (3 Triangulated Light Planes).* University of California Art Museum, Berkeley. March 4–April 29. Catalogue: *Space as Support.* Essay by Mark Rosenthal.
Atkins, R. "Irwin Trips the Light Fantastic." *Art Week* 10 (April 14, 1979):1.
Fischer, H. "Space as Support: Work by Daniel Buren, Robert Irwin, Carl Andre, Maria Nordman." *Artforum* 18 (October 1979).
Jankowski, Wanda. "Seeing Space in a New Light." *Lighting Design and Application* (November 1979).
Christo, Di Suvero, Irwin, Segal. Roy M. Neuberger Museum, State University of New York. April 2–May 21.
Robert Irwin: Untitled Installation (Transient Passage). Helen Forsan Spencer Gallery, University of Kansas, Lawrence. May 1–July 15.
Painting in Environment. Palazzo Real, Comune di Milano, Italy. June 9–September 16. Catalogue: Essay "Painting and Environment, an Inevitable Encounter" by Renato Barilli. Essay "The Explosion of Color-Light in Space" by Francesca Alinovi. Statement by Robert Irwin.
Conference: "Site Sculptors and Landscape Architects Exploring Interdisciplinary Alternatives." Minneapolis College of Art and Design. June 15–16. Catalogue: Essay by Ed Levine. Paper: Project presentation.

XIII Olympic Winter Games (1980 Lake Placid). Project initiated: April. Project presentation: "Tumbling Glass Planes," July 2– September 3. Completed: December.
Robert Irwin: Untitled Installation (Scrim Room Division). San Diego State University, California. July 29–September 1. Knight, Christopher. Review. *Artforum* (October 1979):77–78.
Site Works. Wellesley College, Massachusetts. Project initiated: August. Proposal: "Filigreed Line." Completed: May 1980. Catalogue: *Aspects of the 70's, Siteworks*. Essay by Judith Hoos Fox.
Center for Art and the Environment Sculpture Project. Project initiated: December. 1st proposal: "Pink Glass–Cor-Ten Steel Sanctuary," May 1980. 2nd proposal: "Five Curved Snow Fences," May 1982. 3rd proposal: "H. H. H. Memorial Plaza," April 1983. Project not realized.
Seattle Arts Commission Public Safety Building Plaza. Project initiated: September. 1st proposal: "Three-Ring Maze," December. 2nd proposal: "9 Spaces, 9 Trees," April 1980. Completed: July 1983.
N. E. A. Arts in Public Places: Thirteenth and "O" Streets. Lincoln, Nebraska. Project initiated: October. 1st proposal: "Formal Crossing," February 1980. 2nd proposal: "Second Crossing," November 1980. Project not realized.
56 Shadow Planes. Old Post Office Atrium, Washington, D.C. Project initiated: November. Completed: September 1983.
California Perceptions: Light and Space. California State University, Fullerton. November 16–December 13. Catalogue: "California Perceptions: Light and Space." Essay by Melinda Wortz.

Rosenthal, Mark. *Andre/Buren/Irwin/Nordman: Space as Support*. Berkeley: University Art Museum, 1979.
Wolfe, Clair. "On Art Writing. Part 1: Structuring the Conceptual Environment." *LAICA Journal* (June/July 1979):44–47.

1980 *One Wall Removed*. Malinda Wyatt Gallery, Venice, California. February. Completed: May.
Aviary. Duncan Plaza, New Orleans. In collaboration with I. A. Torre. Project initiated: March. Selection (winner): March 1981. Project not realized.
Contemporary Art From Southern California. The High Museum of Art, Atlanta, Georgia. April 26–June 8. Work installed: Two room installations. Catalogue: *Contemporary Art From Southern California*. Essay by Clark V. Poling.
11th International Sculpture Conference. Washington, D.C. June 4–7. Paper: "Non-Object Art–The Character of Reality" Panel: Monumentality, Sculpture on an Urban Scale.
Permanent Sculpture Installation. Los Angeles County Museum. Project initiated: July 1980. Project proposal: "Street Crossing," October 1980. Project in works.
Untitled Permanent Installation (Window Transformation). Allen Memorial Art Museum, Oberlin College, Ohio. Project initiated: August. Completed: December.
International Symposia On Teaching Art At the Advanced Level. L'Université du Quebec à Montréal, Montreal, Quebec, Canada, August 16–18. Principal speaker ("A Discussion of the Principals of Education").
Drawing: The Pluralist Decade. Institute of Contemporary Art, University of Pennsylvania. October 4–November 9. Also shown at

United States Pavilion, Venice, Biennale, 1980; Museum of Contemporary Art, Chicago, May 1981. Catalogue: *Site Specific Work: Indoors/Outdoors*. Text by Janet Kardon. Essay by John Hallmark Neff.

Evren, Robert. "From Window to Wall: Robert Irwin's Untitled." *Bulletin, Allen Memorial Art Museum* 39,no.1(1982).

1981 West/East. P.S. #1, New York. Project proposal: "Security Stairwell." January 1981. Completed: April 1981.
Philadelphia Tri-Centennial Celebration. Fairmont Park Art Association, Philadelphia, Pennsylvania. Project initiated: April 1981. Project proposal: "Stoop for Philadelphia." October 1981. Project in works.
The Museum As Site–16 Projects–Installation. Los Angeles County Museum of Art. July 21–October 4. Project: "An Exercise in Placement & Relation in 5 Parts." Catalogue: Essay by Stephanie Barron.
Seventeen Artists in the Sixties. Los Angeles County Museum of Art. July 21–October 4. Catalogue: *Visually Haptic Space: Twentieth Century Luminism*. Essay by Michele D. DeAngelus.
Stevens, Mark. Review. *Newsweek* (August 17, 1981):78–79.
Appointment: Visual Arts Policy Panel. National Endowment for the Arts, Washington, D.C. Term: August 1981–July 1983.
Garland Wreath. Fountain Square Atrium, Cincinnati, Ohio. Project initiated: August. Project status: unresolved.
Two Running Violet V Forms. Stuart Foundation Sculpture Collection, University of California, San Diego. Project initiated: October. Completed 1983.
Appointment: John J. Hill Professorship/Lecture Series. University of Minnesota, September 1981. "A Discussion of My Work," October 5. "Art as a Cultural/Social Discipline," October 19. "Reasoning a Non-Object Art," October 27. "Perception as a Source of Creative Development," November 9.

Butterfield, Jan. "The Enigma Suffices." *Images and Issues* 1(Winter 1980–81):38–40.
Celant, Germano. *L'Espace entre parentheses. Art Press International* (France)no.53(November 1981):16–19.
Wortz, Malinda. "Surrendering to Presence, Robert Irwin, Esthetic Integration." *Artforum* 20(November 1981):161–165.

1982 *Conference: Art & Architecture: A Changing Relationship*. University of California, Los Angeles. February 1982. Principal speaker ("Issues of a New Context").
Form and Function: Proposals For Public Art For Philadelphia. Pennsylvania Academy of Fine Arts. February 19–April 18. Catalogue: *The Process*. Essay by Penny Blakin Bach.
Sound Chasing Light. O'Hare Airport, Chicago. Project initiated: April. Project not realized.
Proposal: Nature Walk. Louisiana Museum of Art, Humleback, Denmark. May 1982. Project in works.
Two Ceremonial Gates, Asian Pacific Basin. San Francisco International Airport, California. Project initiated: July. Completed: July 1983.
Rock Garden, Sitting Room. Amtrack Station, Providence, Rhode Island. Architects: Skidmore, Owings & Merrill, Washington, D.C. Project initiated: July. Project not realized.

Conference: Art and Reality. Center for the Arts, Simon Frazier University, Vancouver, British Columbia. August 10–13. Principal speaker ("A Discussion of Terms").
Installation: Light to Solid. Louisiana Museum of Art, Humleback, Denmark. September/October 1982.
Art 82 (France): World Trends 82–Installation. Louisiana Museum of Art,France. Fall 1982. Text by Robert Irwin.
Three Primary Forms. Battery Park City Commercial Plaza, New York. Project initiated: December. Project rejected.

Butterfield, Jan. "New Light on a Socratic Artist." *San Francisco Chronicle* (April 4, 1982):5.
Johnson, Ellen, ed. *American Artists on Art: From 1940 to 1980*. New York: Harper and Row, 1982.
"Robert Irwin: Interview." *Video Data Bank* (Chicago)2(July 1982).
Weschler, Lawrence. "Lines of Inquiry." *Art in America* 70(March 1982):102–109.
———. "Taking Art to Point Zero." *New Yorker Magazine*, pt.1&2(March 8 & 15, 1982).
———. "Robert Irwin: Taking Art to the Vanishing Point." *International Herald Tribune* (September 25, 1982):6.
———. *Seeing is Forgetting the Name of the Thing One Sees*. Berkeley and Los Angeles: University of California Press, 1982.

1983 Thompkins, Calvin. "Like Water in a Glass." *New Yorker Magazine* (March 21, 1983).

1984 *MacArthur Fellowship 1984–1989*.
A Single Plane: 324 Parts. San Francisco Museum of Modern Art, California. Project initiated: May. Completed: September 1985.

Harris, Stacy P. *Insights/On Sites: Perspectives on Art in Public Places*. Washington D.C.: Partners for Livable Places, 1984.
McEvilley, Thomas. "Robert Irwin, Public Safety Building, Old Post Office." *Artforum* 22(June 1984):96.

1985 *Grand Avenue Viaduct*. Los Angeles, California. Project initiated: January. Project pending.

Being and Circumstance was designed by Jack W. Stauffacher of the Greenwood Press, San Francisco, California. Type is Meridien, designed by Adrian Frutiger. Text photocomposition by Kina Sullivan, San Francisco. Printed by Gardner/Fulmer Lithograph, Buena Park, California.